THE GRAPHIC DESIGN PORTFOLIO

THE GRAPHIC DESIGN PORTFOLIO:

HOW TO MAKE A GOOD ONE

PAULA SCHER

Watson-Guptill Publications/New York

Editor: Paul Lukas
Senior Editor: Candace Raney
Designer: Paula Scher
Layout: Jay Anning
Graphic Production: Ellen Greene

First published in 1992 by Watson-Guptill
Publications,
a division of BPI Communications, Inc.,
1515 Broadway, New York, NY 10036

**Library of Congress Cataloging-in-
Publication Data**
Scher, Paula.
 The graphic design portfolio :
 how to make a good one / Paula Scher.
 Includes index.
 ISBN 0-8230-2162-9
 1. Commercial art—Marketing.
 I. Title. NC1001.S34 1992
 741.6'068'8—dc20
 91-43771 CIP

Manufactured in Singapore

First printing, 1992

1 2 3 4 5 6 7 8 9 / 98 97 96 95 94 93 92

For All My Students—For All My Teachers

'd like to thank Paul Lukas, Candace Raney, and all the people at Watson-Guptill who aided in the editing and production of this book, as well as Jay Anning, who facilitated the layout and mechanicals.

I would like to thank Olga Schubart for her tireless patience in typing my scrawled manuscript, and Ron Louie and David Matt (former students both), who helped me format the book and design the jacket.

Heartfelt thanks also go to Silas Rhodes, David Rhodes, and Richard Wilde from the School of Visual Arts, who encouraged me to be myself and allowed me to structure a course that best suited my abilities.

Finally, I would like to thank all of my students who generously provided me with their work. In the end I've learned more from them than they have from me.

PREFACE

In the early 1980s, I began teaching a Senior Portfolio class at the School of Visual Arts in New York. The course, which is required for all graduating seniors majoring in graphic design, serves as a link between a graphic design education and a graphic design career. The goal of the course is to help students prepare a portfolio—a cohesive presentation of their work—that they can show to prospective employers in the hopes of finding an entry-level graphic design position.

The School of Visual Arts encouraged me to structure the course in any way I saw fit to accomplish this goal. This turned out to be something of a challenge, since one of my initial discoveries was that many of the students entering the senior-year program do not yet possess the design skills needed to complete the pieces for their portfolios. In attempting to address this deficiency, I have learned that the maturation processes of young designers can differ dramatically. Some designers don't find their own creative voice until relatively late in their schooling, while others find it early but don't grow very much afterwards. Every student is different.

In other respects, the students are very similar. On the one hand, they all share a genuine fear about entering the job market; on the other, they tend to think there is some sort of simple formula to making a successful portfolio that will result in professional fame and fortune. Most of them believe that if their portfolio pieces are well matted, covered in acetate, or laminated and positioned in a beautiful box, the pieces themselves will magically become terrific, leading to a good job and a quick road to professional stardom.

My students also seem to believe that the completion of their portfolios means they are "done," almost like a loaf of bread coming out of the oven. After all, they have completed their portfolios and earned their degrees, so they must now be viable designers.

I realized that in order for my instruction to be useful and successful, all these notions would have to be dispelled. The students must understand that a design career is an ongoing process of learning and growth, and that a school portfolio is only a means to a beginning, not an end in itself. They also must learn to measure the value they attach to a "finished" piece in the larger context of the value of learning to design, and to understand that every design represents a piece of knowledge. This learning process entails growth, and

growth inevitably leads to the difficult task of discarding past solutions. Designs that seemed brilliant a semester ago may appear simplistic and one-dimensional as a designer's skills advance, but most students are reluctant to acknowledge that their favorite early successes are anything less than wonderful. Ultimately, this tendency becomes a hindrance. Students only get better if they can let go of the protectiveness of their past work.

With all of this in mind, I began to construct a number of assignments that would teach my students the skills they needed. They would learn by doing, but they would not actually be allowed to finish any of their work until the end of the year, when their skills were more advanced. Instead, they would work in rough comp form and finish each piece only after making all the design decisions to the best of their abilities.

This approach had several aims. On a practical level, keeping all of the assignments alive at some intermediate stage while the students' skills were still developing would allow them to make their final judgments and design decisions when their talents were a bit more mature. In addition, each new assignment would contribute to the learning process and thereby lead to renewed thought about the other in-progress assignments. And by preventing any piece from being completed until the end of the

course, I hoped to avoid the common sentimental attachment to early work. This method has been successful: Most students improve so dramatically during the school year that they end up redoing everything, completing their entire portfolios over the course of the last month of class.

The assignments are structured not only to teach specific skills, but also to provide potential employers with a clear picture of what skills these students had acquired. I emphasize layout and editorial design, promotional design, cover design, poster design, and some packaging. These areas offer the best opportunities for a young designer seeking an entry-level position in New York, and are the areas in which I have done most of my professional work, so I knew them best.

In fact, most of the problems are based on jobs I originally did myself. This allows me to discuss the assignments in the broader context of the marketplace, the business side of things, the way corporations function, and the way things are produced, thereby creating a bridge between the student and professional worlds.

This book contains some of the assignments I gave to my class; it is illustrated with student work. Each assignment is presented as it was originally given, accompanied by some of the thought and working processes involved in completing it. While the assignments make for a nice

framework and provide an adequate balance of the amounts and types of work that might be shown in a successful portfolio, my intent here is not for this book to be followed blindly—the assignments serve only as guides. They can and should be reconstructed to meet individual needs.

These assignments are for senior design students (or advanced juniors) and young professionals who would like to improve their portfolios. Anyone attempting them should have firm understandings of typography, layout, and the ability to conceptualize.

What is *not* presented here, and what no book can provide, is the classroom aspect of preparing a portfolio. I teach the class through an intensive critique of each student piece; the students work independently and then make revisions based on classroom discussion. By the end of the year, the talented students become very adept at critiquing themselves. And this reinforces a hard truth: Not all students become good; only the talented ones do. They are the students who learn to see, while the others never do.

INTRODUCTION:
ARNING TO DESIGN

My Senior Portfolio course is constructed to function as a practical beginning to a graphic design career. It does not deal in design theory specifically but does address theory as it relates to application. Some of the assignments are constructed for convenience. The *New York Times* assignment, for example, helps the student address typography and layout problems from a practical standpoint, and also imparts skills and knowledge that will prove particularly handy when the student is confronted with a magazine design project.

When I consider my students' work over the years, I can see where I have been an effective teacher, and also where I have failed. I have always had an easy time helping my students master typographic design, for instance, but motivating them to come up with good ideas has been much more difficult. Any student with a modicum of taste and intelligence can be taught to lay out a page well; it is far more difficult to teach someone to think.

Other limitations are inherent to the nonprofessional nature of any classroom work: My students, unfortunately, cannot draw well for the most part, and they are obviously in no position to commission illustration or photography, so they rely on found imagery to express ideas and are generally limited by what they find. These restrictions lead the students to limit their creative thinking—they tend not to consider approaches that cannot be produced effectively for their portfolios. I consider this to be the great failure of my class. It may also become the great failure of a future generation of designers who have learned to design on a computer instead of by attacking problems with a pencil and paper—their imaginations tend to be limited by what is available.

Teaching and learning can also be limited by factors far beyond the reach of my classroom. I find my students are very concerned that their portfolio works "look good"—meaning that they want the pieces to appear well designed, well presented, and contemporary—but they tend to have little interest in the *content* of the work. Unfortunately, this disinterest is neither tremendously surprising nor unique to graphic design students among today's young people—it is a general result of the American education system and of our society. Most young designers I have encountered are passionate about design and about very little else. They are not very well-read, have little apparent interest in current affairs (or any other subject matter),

and are not particularly knowledge-able about popular American culture.

Most students in my class know who Paul Rand is, for example, but when I assigned a book series on American humorists, none had even heard of Dorothy Parker or H. L. Mencken. Aside from what this may say about the American primary and secondary educational agenda, I think it illustrates a skewed sense of priori-ties for anyone planning a career in graphic design. How can young designers create visual analogies, metaphors, clichés, puns, and similes if their cultural vocabularies are so limited? I find it odd that some of my students have committed every type-face to memory but have never seen *Casablanca*.

Ultimately, the portfolio class is an exercise that prepares students for future employment and gives them some practical skills for accomplish-ing certain design tasks. But it is not the foundation for the career of an innovative and inspirational designer, and it is no substitute for an imagina-tive mind. The student designer with a great creative future will have a natu-ral inquisitiveness about the world at large; the strong teacher will motivate the students to have broader interests.

____ What Your Portfolio Can ____ and Can't Do for You

The dictionary defines *portfolio* as "a hinged cover or flexible case for carrying loose papers, pictures or pamphlets." To a design student, however, a portfolio essentially con-sists of its contents: a representation-al body of work that the student will bring when knocking on doors of potential employers in the hopes obtaining professional work.

There is no formula for what belongs in a successful portfolio. A good portfolio clearly illustrates the strength of the designer. Does the designer understand layout and typog-raphy? Does he or she have good ideas? What about technical exper-tise? Does the designer have at least a rudimentary understanding of solving problems as they relate to the poten-tial employer's business?

Moreover, a good portfolio will mean different things to different peo-ple. An art director of a magazine will judge a portfolio differently than an art director at an advertising agency or at a corporate design firm. Knowing this, a design student with a specific interest should create samples reflect-ing that interest.

Most students, however, have not yet selected a specific specialty area of design and tend to be generalists. This is not a flaw and should not be seen as such—I believe most good designers are generalists, which means they can solve any problem. Unless a student is very clear about having a specialty and is willing to devote considerable commitment to that type of design, having a focus area can limit the possibilities.

All work in a portfolio—15 to 25 pieces, ideally—should be of equal caliber. If a student produces 20 pieces but recognizes that only 14 are good enough for portfolio inclusion, then only the 14 top-notch pieces should go into the portfolio. Don't make the mistake of trying to cover all the bases at the expense of quality—a poor editorial design sample is *not* better than no editorial design sample at all.

Try to play Devil's advocate when assessing what a portfolio piece really demonstrates to a prospective employer. For example, some individual design pieces—posters, for example—work well by themselves, but one isolated spread from a magazine is completely irrelevant. What if the story had run for five spreads—would the designer have been able to follow through?

The portfolio should be accessible, not cumbersome. Anyone viewing it should be able to understand the work without a running commentary of explanations from the student. If a piece of work can't be understood on its own merits, don't include it—it should be strong enough to speak for itself. Besides, students cannot assume that they will be present when their portfolios are reviewed by their potential employers—they should expect to drop off their portfolios and pick them up later. If a portfolio is strong enough, it will elicit a positive response or an invitation for an interview.

Potential employers are often interested in knowing if a design student has had any professional experience. Many design students take free-lance design jobs while in school and have printed samples of such work. Unfortunately, these free-lance jobs often entail poor design standards, forcing the students to produce subpar work.

A student in this situation should position the printed work in a side pocket of the portfolio with a note explaining the circumstances of the job. Any reasonable, intelligent employer will readily understand the situation and will be more interested in fact that the student has had some real-world experience than in judging the free-lance work too harshly.

Some employers like to see evidence of the thought process. If you have kept a sketchbook of your ideas while preparing your portfolio, and it can be readily understood, include it in a side pocket.

An employer who likes your work and has a job opening available will probably invite you to an interview; an employer who likes your work but has no job openings may offer to refer you to other potential employers. In either event, congratulate yourself, and be justifiably proud of your portfolio—if it gets you this far, it has done its job. Remember, a portfolio cannot conduct an interview for you or perform for you on the job. It can only get you in the door.

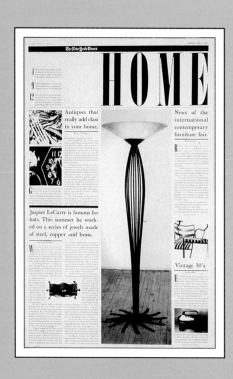

The Assignment:
Redesign the cover pages
of the five special weekday
sections of the *New York
Times:* "SportsMonday,"
"Science Times," "The
Living Section," "Home,"
and "Weekend."

Newspaper Design

Newspaper redesign offers perhaps the best way for young designers to demonstrate their organizational abilities. I used the front pages of the *New York Times*'s special sections as a basis for the class assignment, but any similarly structured newspaper will do. The challenge here involves the classic graphic design balance between aesthetic attractiveness and functional practicality: ordering groups of visual and verbal information so that the front page has a dynamic impact, can be perceived as one beautifully designed page, and presents all the information in an accessible and easy-to-read fashion.

The *New York Times* is a serious newspaper, of course, but these daily special sections are the fluff, featuring movie reviews, home decorating columns, recipes, the television guide, the crossword puzzle, and so on. Their purpose is to offer entertainment and light items of general interest, not hard news, and they therefore attract lots of advertising, which provides significant financial support for the newspaper. A student approaching the assignment must have a clear understanding of all of this, and should keep in mind both the editorial and fiscal goals of these pages.

Page 14: Claudia Gnaedinger's *New York Times* design relies on a strong grid system, with the section logo appearing flush-right under a black band. Note the clever positioning of the *Times* logo, which drops out of the black band.

—— **Taking Liberties with the *Times*** ——

The *New York Times* is already a well-designed newspaper, so anyone assigned to redesign it faces a tough standard. The text face of the special sections (and throughout the paper) is Times Roman; while it is unlikely that the *Times* would change its text face, we will allow (but not require) such a change in the context of the assignment. We will also standardize the design of section logos—they are currently quite distinct—to create a greater unity among the various section cover designs. To facilitate this, we will change the section headings as follows: "SportsMonday" will be called "Sports"; "Science Times" will be called "Science"; and "The Living Section" will be called "Living."

Because it is not our goal to change the demographic makeup of the paper's readership, we will refrain from modernizing or otherwise drastically altering the design in a way that would signal a change in audience. In reality we enter a danger zone here, since any change in design can inadvertently signal or imply a change in content. For the purpose of the assignment, then, let's simply state that we will redesign the *Times* so as

not to lose its current elegance and functionality. The image of the *Times* is classy, not trendy—we can make the paper more elegant and lively, but we don't want to turn it into *Rolling Stone* or *Beach Culture*. We must also recognize that this is a daily newspaper, and the design therefore must be simple enough to be produced every day without high production costs. Color, therefore, is not allowed, and the design should steer clear of complicated, hard-to-read letterspacing or intricate typographic headings that would be difficult to produce on tight daily deadlines.

—— Getting Started ——

The best way to approach the redesign of anything is to familiarize yourself with it thoroughly. In this instance, the easiest way to do this is to buy the subject and read it. And I do mean *read* it—don't just look at it. When laying out and organizing information, it is impossible to do a decent job without a good idea of what the information actually is. While student comps inevitably contain dummy text, the ultimate goal is for the design to house real articles, laid out intelligently. And the best way to achieve this is to become a reader yourself.

The first step is to review the design elements that typically appear on the front page of the special sections, and to consider how they might be adjusted or employed differently. These visual components include the following:

1. The *New York Times* logo

2. The day and date

3. The section logo (e.g., Living, Weekend, etc.)

4. An abbreviated index of the section's contents, sometimes with accompanying photographs

5. Headlines for each of the front-page articles

6. Three front-page articles that continue inside the section

7. Several photographs and/or illustrations accompanying these articles

8. A byline (the author's name) for each article

9. A continued line at the end of each article's front-page run

10. A caption for each photograph (but not for illustrations)

11. One or two pull quotes (a phrase or sentence from an article, "pulled out" and highlighted in larger type to

attract readers and draw the eye into the article)

12. Credit lines for photographs and illustrations

13. A section copyright line

Additionally, the following optional components sometimes appear:

1. *Cap initials*: A large capital letter, usually at the start of the article, used to indicate the beginning of the text or a departure from the subject matter

2. *Subheads*: Explanatory headlines appearing below the primary article headlines, and set in a smaller typeface

3. *Charts or maps*: Visual information that may accompany an article but can be read and understood on its own

If you spend some time reading the *Times*, you probably will find things in its organization that bother you. These are the areas you can attempt to improve upon. Here are questions you will want to address immediately:

1. Is it clear where the article begins? Often, the headline is separated from the rest of the text by a photograph or some other element, and it's annoying to have to jump around to find it.

2. Do the images relate to the specific articles they illustrate? Are they well positioned, so the reader can make the proper association?

3. If the text runs in more than one column, does your eye move easily from the bottom of the first column to the top of the next one?

4. If an article's opening paragraph is set in a larger type size than the rest of the article, is there a smooth, easy transition to the normal type size, or does the transition ultimately make the larger type counterproductive?

5. Is it reasonably easy to differentiate one article from the next, based on their organization and positioning?

6. Is it reasonably easy to locate the index?

7. Does the newspaper function effectively when folded in half or in quarters? The designer should remember that newspapers, especially the *Times*, are often read on crowded trains. To get an idea of the design implications of this, take a copy of the *Times* into a crowded New York City subway during rush hour and read it there.

With these considerations in mind, you can begin your design. There is no set order or sequence in which you should approach the logo, the typography, the grid, and the other design elements involved in the project. These should all be considered throughout the entire process.

—— **Designing a Logo** ——

When creating the section logos, the designer must select a type style that is equally powerful for each of the five section titles. *Weekend* is the longest heading and *Home* is the shortest, so it is best to begin with these two words when selecting a logo typeface. Because we are standardizing all the titles, positioning becomes important. If the goal is to position each logo straight across the top of the page, *Weekend* will fit nicely, but *Home* won't. If *Home* is enlarged enough to extend across the page, the resulting type size may be too big, unless the type is very round or somewhat extended.

The logos' letterforms are very important. Note, for instance, that *Weekend* has a lot of *e*s; *Sports* and *Home* each contain an *o*. These letters can become very noticeable in the finished design.

Other factors affect logo typeface selection as well. The designer must consider the following:

1. Newsprint—the paper used for newspapers—does not give optimal print reproduction quality (in fact, it's the worst). Given this limitation, avoid typefaces that are too thin and light, since their delicate features may not survive the printing process. Also avoid gray halftone typographic elements, such as drop shadows or outline letterforms filled in with halftone tints—these will appear muddy.

2. Avoid typefaces that are overly condensed or overly extended; they are often difficult to read.

3. Consider whether the logos will set in all capital letters or in upper- and lowercase.

4. Avoid scripts, complicated ligatures, or trendy typefaces, all of which are inappropriate for a daily newspaper in general and for the *Times* in particular.

With all of these considerations in mind, there are a number of typefaces that can be employed to produce handsome logos. Among the serifs, the following work nicely: Bodoni Book; Bodoni Bold; Bodoni Bold Condensed, either as capitals (caps) or upper- and lowercase (u/lc); Garamond #3, caps or u/lc; Baskerville, caps or u/lc; the Caslons, caps or u/lc; Cheltenham Oldstyle Bold, caps and u/lc; and the Centuries—Oldstyle, Expanded, Bold, and Bold Condensed—in caps.

Among the sans serifs, try Futura Bold, Medium, Book, Condensed or Regular; Spartan Bold; Gill Sans; and Franklin Gothic Regular, Condensed, Extra Condensed, and Expanded.

These are by no means the only viable faces for the logos, but they serve as a good starting point.

The New York Times Thursday, May 2, 1991

LIVING

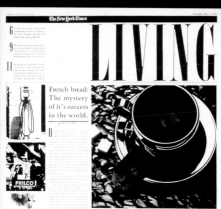

6
9
11

French bread:
The mystery
of it's success
in the world.

The English tradition continues in style despite
the discovery of tons of tea-bags from Japan.

Costumes of
an extravagant
Performance

A World worth Saving. The original Italian bakery is an
oasis in between the business of the metropolis.

160 - VESÚVIO BAKERY - 160

Copyright © 1991 The New York Times Friday, May 4, 1991

The New York Times

WEEKEND

8 IT DID NOT OCCUR TO ME THAT
EVERYTHING WAS NOT AS IT SHOULD
BE, UNTIL SEVERAL SECONDS HAD

12 OVER AND FALL HEADFIRST. I LOOK-
ED AROUND AT THE CHUTE JUST IN
TIME TO SEE IT STRING OUT, THEN
THE HARNESS JERKED ME INTO AN

34 THE COMFORTABLE TUG OF THE
RISERS WHICH USUALLY FOLLOWS AN
EXHIBITION JUMP. AS I NEVER MADE

The Ballerina from Catalina

By James W. Hall

Miles is Black, Black is Miles.

By David Butts

One hundred years of music at Carnegie.

By Susan Hall

Anton Corbijn photographs music's most famous names from James Brown to Tom Waits

By Robert Lee Rose

Drawing of the Mirror by Michelangelo Pistoletto.

By Gregory Jones

Like her "Home" section
(see page 14), Claudia
Gnaedinger's remaining
Times pages employ a
consistent grid system.
The section logos appear
in a condensed serif
typeface and remain at a
constant width, despite
the varying number of
letters in the section
titles. The upper-left col-
umn houses the indexing
information, while a con-
sistent hole of white
space between the index
and the logo creates a
special elegance. The
repetition of the black
bands and large, serifed
pull quotes give the
broadside its unique
look.

SCIENCE

Photography of Space in Exploration.

By Andrew Grove

Voyager II- visited Neptune, Jupiter, Saturn and Uranus

By Ricardo Luis Rojas

Prehistoric fossils communicate from the past

By Susan Hart

SPORTS

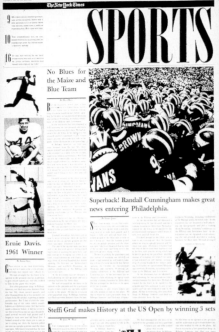

No Blues for the Maize and Blue Team

Superback! Randall Cunningham makes great news entering Philadelphia.

Ernie Davis. 1961 Winner

Steffi Graf makes History at the US Open by winning 5 sets

SCIENCE

SPACESHIP

Mission to a Small Planet

BY JOHN APPLE

P The main purpose of letters is the practical one of making thoughts visible. Ruskin says that all letters are frightful things and to be endured only on occasion, that is to say, in places where the sense of the inscription is of more importance than external ornament. This is a sweeping statement, from which we need not suffer unduly; yet it is doubtful whether there is art in individual letters. The main purpose of letters is the practical one of making thoughts visible. Ruskin says that all letters are frightful things and to be endured only on occasion, that is to say, in places where the sense of the inscription is of more importance than external ornament. The main purpose of letters is the practical one of making thoughts visible. Ruskin says that all letters are frightful things and to be endured only on occasion, that is to say, in places where the sense of the inscription is of more Importance ornament. The main purpose of letters is the practical one of making thoughts visible. Ruskin says that all letters are frightful things and to be endured only on occasion, that is to say, in places where the sense of the inscription is of more importance than external ornament. This is a sweeping statement, from which we need not inn

The main purpose of letters is one the practical ones of making thoughts visible. Ruskin says that all letters ■

Continued on Page 14A

USA

15

In purpose of letters is the of making thoughts visible. Ruskin says that all letters are frightful things and to be endured only on occasion, that is to say, in places where the sense of the inscription is of more importance th ■

19 external ornament. This sweeping statement, from we need not suffer unduly; yet it whether there is art in indiv main purpose of letters is ■

Battling the Legacy of Illness

BY ARLENE GRANET

R The main purpose of letters is the practical one of making thoughts visible. Ruskin says that all letters are frightful things and to be endured only on occasion, that is to say, in places where the sense of the inscription is of more importance than external ornament. This is a sweeping statement, from which we need not suffer unduly; yet it is doubtful whether there is art in individual letters. The main purpose of letters is the practical one of making thoughts visible. Ruskin says that all letters are frightful things and to be endured only on occasion, that is to say, in places where the sense of the inscription is of more Importance ornament. The main purpose of letters is the practical one of making thoughts visible. Ruskin says that all letters are frightful things and to be endured only on occasion, that is to say, in places where the sense of the inscription is of more importance than external ornament. This is a sweeping statement, from which we need not suffer unduly; yet it is doubtful whether there is art in individual letters. The main purpose of letters is the practical one of making thoughts visible. Ruskin says that all letters are frightful things and to be endured only on occasion, that is to say, in places where the sense of the inscription is of more Importance ornament. The main purpose of letters is the practical one of making thoughts visible. Ruskin says that all letters are frightful things and to be endured only on occasion, that is to say, in places where the sense of the inscription is of more importance than external ornament. This is a sweeping statement, from which we need not suffer unduly; yet it is doubtful whether there is art in individual letters. The main purpose of letters is the

Continued on Page 21D

4754

FOOD ALLERGIES
A Growing Controversy

BY BERNADINE WOLFF

S The main purpose of letters is the practical one of making thoughts visible. Ruskin says that all letters are frightful things and to be endured only on occasion, that is to say, in places where the sense of the inscription is of more importance than external ornament. This is a sweeping statement, from which we need not suffer unduly; yet it is doubtful whether there is art in individual letters. The main purpose of letters is the practical one of making thoughts visible. Ruskin says that all letters are frightful things and to be endured only on occasion, that is to say, in places where the sense of the inscription is of more Importance ornament. The main purpose of letters is the practical one of making thoughts visible. Ruskin says that all letters are frightful things and to be endured only on occasion, that is to say, in places where the sense of the inscription is of more importance than external ornament. This is a sweeping statement, from which we need not suffer unduly; yet it is doubtful whether there is art in individual letters. The main purpose of letters is the practical one of making thoughts visible. Ruskin says that all letters are frightful things and to be endured only on occasion, that is to say, in places where the sense of the inscription is of more Importance ornament. The main purpose of letters is the practical one of making thoughts visible.

Continued on page 12

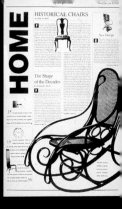

WEEKEND

The main purpose of letters is one the practical ones and

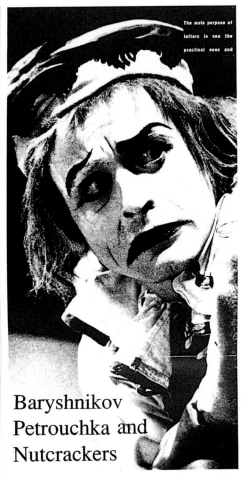

Baryshnikov Petrouchka and Nutcrackers

15 The main purpose of letters is the

19 practical one of making thoughts

27 visible. Ruskin says that all letters

36 are frightful things and to be

endured only on occasion, that is to say, ■

The main purpose of letters is the practical one of making thoughts visible. Ruskin says that all letters are frightful things and to be endured only on occasion, that is to say, in places where the sense of the inscription is of more importance than external ornament. This is a sweeping statement, from which we need not suffer unduly; yet it is doubtful whether there is art in individual letters. The main purpose of letters is the practical one of making thoughts visible. Ruskin says that all letters are frightful things and to be endured only on occasion, that is to say, in places where the sense of the inscription is of more importance ornament. The main purpose of letters is the practical one of making thoughts visible. Ruskin says that all letters are frightful things and to be endured only on occasion, that is to say, in places where the sense of the inscription is of more

Importance ornament.-The main purpose of letters is the practical one of making thoughts visible. Ruskin says that all letters are frightful things and to be endured only on occasion, that is to say, in places where the sense of the inscription is of more importance than external ornament. This is a sweeping statement, from which we need not suffer unduly; yet it is doubtful whether there is art in individual letters. The main purpose of letters is the practical one of making thoughts visible. Ruskin says that all letters are frightful things and to be endured only on occasion, that is to say, in places where the sense of the inscription is of more Importance ornament. The main purpose of letters is the practical one of making thoughts visible. Ruskin says that all letters are frightful things and to be endured only on occasion, that is to say, in

Continued on Page 16B

26 sweeping statement, from which we
need not suffer unduly; yet it is doubtful
whether there is art in individual letters. ■

whether there is art in ind
main purpose of letters is the pr
making thoughts visible. Ruski

36

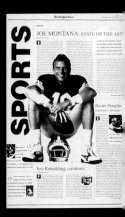

Folk Art Festival Exhibition Opens

BY JOAN KLEIMAN

V The main purpose of letters is the practical one of making thoughts visible. Ruskin says that all letters are frightful things and to be endured only on occasion, that is to say, in places where the sense of the inscription is of more importance than external ornament. This is a sweeping statement, from which we need not suffer unduly; yet it is doubtful whether there is art in individual letters. The main purpose of letters is the practical one of making thoughts visible. Ruskin says that all letters are frightful things and to be endured only on occasion, that is to say, in places where the sense of the inscription is of more Importance ornament. The main purpose of letters is the practical one of making thoughts visible. Ruskin says that all letters are frightful things and to be endured only on occasion, that is to say, in places where the sense of the inscription is of more importance than external ornament. This is a

Continued on page 12

New Dancing Gems

BY JOHN APPLE

P The main purpose of letters is the practical one of making thoughts visible. Ruskin says that all letters are frightful things and to be endured only on occasion, that is to say, in places where the sense of the inscription is of more importance than external ornament. This is a sweeping statement, from which we need not suffer unduly; yet it is doubtful whether there is art in individual letters. The main purpose of letters is the practical one of making thoughts visible. Ruskin says that all letters are frightful things and to be endured only on occasion, that is to say, in places where the sense of the inscription is of more Importance ornament. The main purpose of letters is the practical one of making thoughts visible. Ruskin says that all letters are frightful things and to be endured only on occasion, that is to say, in places where the sense of the inscription importance than external ornament. sweeping statement, from which we need unduly; yet it is doubtful w! individual letters. The main p practical one of making the

Continued on Page 17C

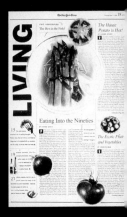

Ultimately, of course, the distinct character of a typeface does not exist in a vacuum—it comes from the way a designer applies it to a page.

—— Typography ——

The immediately preceding comments about the logo typography notwithstanding, it is not my intention here to teach the rudiments of typographic design. Any senior year student should have learned this well in advance of reaching my class. However, the *New York Times* assignment is the perfect place to hone typographic skills: Most of the page-makeup components are typographic, and the page design relies on the balance and scale of different typographic weights and sizes coupled with visual imagery. In short, the task of designing a front page ultimately becomes the complicated art of typographic layout.

Because type selection is crucial to the assignment's success, designers with weak typographic skills may be intimidated by it. Don't be—this is one of the best ways to learn how to work with typography. The secret is in limiting your type choices. While type specimen books are filled with hundreds of typefaces, most designers work within a limited framework. If you are uncomfortable with type, stick to two or three well-designed faces. The success of a well-designed page depends more on size, weight, scale, and texture than on a plethora of faces.

—— Creating a Grid System ——

In order to lay out the contents of the page, the designer will have to establish a working grid. The grid is the underlying structure of the page. To develop it, the designer must establish the text column widths and how many columns will fit on the page. Once the basic grid system is established, the designer may choose to complicate it by establishing flexibility within the grid. For example, the design may allow a column to be cut in half to allow for a small picture and a caption, or one column may be extended to two-column width to house an index, a photo, a headline, or larger type at the beginning of an article. As essential as the grid is to the page, the grid on a well-designed page will essentially become invisible, and only the design will show through.

—— Found Images ——

A good selection of visual material will help the finished presentation of the newspaper design immensely, and will also help the designer achieve a more dynamic layout. Don't worry about your illustration or photography skills, and don't commission work

to appear in your assignment—just use scrap images, or found art. There is nothing wrong with this approach, as long as you make your image choices carefully. Aside from the obvious objective of choosing images that relate to the subject matter at hand, also try to use photos that will reproduce well in a black-and-white halftone format. Here are some guidelines that should be helpful when choosing images for each of the special sections:

1. "Sports"—Athletes in action always look terrific. Sports pictures are generally easy to find in sports magazines and books. Consider photographs that are not too grainy and images with strong shapes that can be silhouetted successfully. If your page layout relies on one big, central element, you may want to complement it with a small, busier photograph (a large photo of a base-ball player against a small aerial shot of a stadium, for example).

2. "Science"—Science pictures are trickier than sports images. Avoid complicated shots of the cosmos or indistinct cells, which often come out muddy and are difficult to identify. Botany photos work well, as do charts of molecular structures, the solar system, and so on. If you choose to reproduce existing charts and diagrams, make sure they are well designed.

3. "Living"—This page presents a fine opportunity to showcase gorgeous still lifes of food. When using such a photo, be sure that the appeal of the image does not depend too heavily on color—even the most appetizingly festive food presentation can look ordinary when shown in black and white.

4. "Home"—This is really an interior and exterior design section, so photographs of homes, furniture, housewares, and so on are all acceptable. Naturally, make sure the objects you select are beautiful—there is nothing worse than an otherwise well-designed page ruined by a poor photograph of an ugly chair.

5. "Weekend"—This page offers an opportunity to employ pictures of movie stars, dancers, and scenes from around town, available in dozens of mainstream general-interest magazines.

When you complete your portfolio and show your *New York Times* to potential employers, everyone will know that you worked with found photographs and dummy text. Make no attempt to conceal this fact—it will be clear that your *Times* was a school assignment, that you did not work with an editor, that you did not hire a photographer or illustrator, and that you did not get paid. Don't worry about the images not being original.

ARTS
The main purpose of e of making thoughts The main purpose of e of making thoughts

D 7

ARTS
The main purpose of le e of making thoughts The main purpose of l

D 7

DANCE
The main purpose of letters is e of making thoughts visible. The main purpose of letters e of making thoughts

D 7

Living

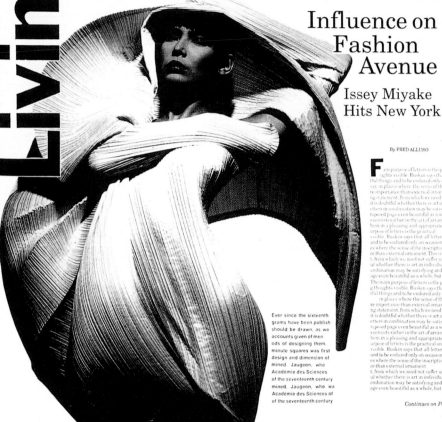

Influence on Fashion Avenue

Issey Miyake Hits New York

By FRED ALLUSO

Fam purpose of letters is the practi nights visible. Ruskin says that all tful things and to be endured only on oc say, in places where the sense of the ins re importance than external ornament ng statement, from which we need not s it is doubtful whether there is art in indi etters in combination may be satisfying toposed page even beautiful as a whole, s consists rather in the art of arranging hem in a pleasing and appropriate man urpose of letters is the practical visible Ruskin says that all letters are and to be endured only on occasion, that es where the sense of the inscription is o ce than external ornament. This is a sw t, from which we need not suffer unduly ul whether there is art in individual lett ombination may be satisfying and in a age even beautiful as a whole, but art in The main purpose of letters is the practi g thoughts visible. Ruskin says that all tful things and to be endured only on oc in places where the sense of the ins re importance than external ornament. ng statement, from which we need not s it is doubtful whether there is art in indi etters in combination may be satisfying toposed page even beautiful as a whole, s consists rather in the art of arranging hem in a pleasing and appropriate man urpose of letters is the practical one of m visible. Ruskin says that all letters are and to be endured only on occasion, that es where the sense of the inscription is o ce than external ornament t, from which we need not suffer unduly ul whether there is art in individual lett ombination may be satisfying and in a age even beautiful as a whole, but art in

Ever since the sixteenth grams have been publish should be drawn, as we accounts given of men ods of designing them. minute squares was first design and dimension of mined. Jaugeon, who Académie des Sciences of the seventeenth century mined. Jaugeon, who wa Académie des Sciences of of the seventeenth century

Continues on Page 7

Make-up That Leads Two Lives

By JOHN JAMES

Dn purpose of letters is the practi hts visible. Ruskin says that all tful things and to be endured only on o say, in places where the sense of the in re importance than external ng statement, from which we need not s it is doubtful whether there is art in in etters in combination may be satisfyin niposed page even beautiful as a whole s consists rather in the art of arranging hem in a pleasing and appropriate ma urpose of letters is the practical one of Ruskin says that all letters are and to be endured only on occasion, tha es where the sense of the inscription is ce than external ornament. This is a sw t, from which we need not suffer undul ul whether there is art in individual le

The main purpose of letters is the pract g thoughts visible. Ruskin says that all tful things and to be endured only on o say, in places where the sense of the in re importance than external orname ng statement, from which we need doubtful whether there i etters in combination may toposed page even beau s consists rather in

Ever since the sixteenth century, el grams have been published to sho hould be drawn, as we shall lear ounts given of men who suggest designing them. Generally ares was first made, an mension of each lette n, who was appoi es of Paris

Continues on Page 15

Stacks of Hats

By JAMES SHAH

Hin purpose of letters is the practi hts visible. Ruskin says that all tful things and to be endured only on say, in places where the sense of the in re importance than external ornament. ng statement, from which we need not s it is doubtful whether there is art in indi etters in combination may be satisfyin niposed page even beautiful as a whole hem in a pleasing and appropriate man urpose of letters is the practical one of m visible. Ruskin says that all letters are and to be endured only on occasion, tha es where the sense of the inscription is o ce than external ornament. t, from which we need not suffer undul ul whether there is art in individual let ombination may be satisfying and in a age even beautiful as a whole, but art i

The main purpose of letters is the practi g thoughts visible. Ruskin says that all tful things and to be endured only on say, in places where the sense of the inv re importance than external ornament. ng statement, from which we need not s it is doubtful whether there is art in indi etters in combination may be satisfyin toposed page even beautiful as a whole, s consists rather in the art of arranging urpose of letters is the practical one of visible. Ruskin says that all letters are and to be endured only on occasion, tha es where the sense of the inscription is o ce than external ornament. t, from which we need not suffer undul ul whether there is art in individual let ombination may be satisfying and in a age even beautiful as a whole, but art i The main purpose of letters is the practi g thoughts visible. Ruskin says that all tful things and to be endured only on oc say, in places where the sense of the inv re importance than external ornament. ng statement, from which we need not s it is doubtful whether there is art in ind etters in combination may be satisfyin toposed page even beautiful as a whole, s consists rather in the art of arranging hem in a pleasing and appropriate man urpose of letters is the

Continues on Page 10

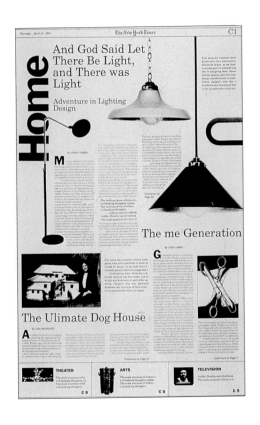

Home

And God Said Let There Be Light, and There was Light

Adventure in Lighting Design

By LYNDA O'HARA

The me Generation

By JOHN JAMES

The Ulimate Dog House

By CARL WEATHERS

THEATER — The main purpose of letters is of making thoughts visible. The main purpose of letters is of making thoughts.
C 9

ARTS — The main purpose of letters is of making thoughts visible. The main purpose of letters is of making thoughts.
C 9

TELEVISION — visible. Ruskin says that in us. The main purpose of letters is
C 9

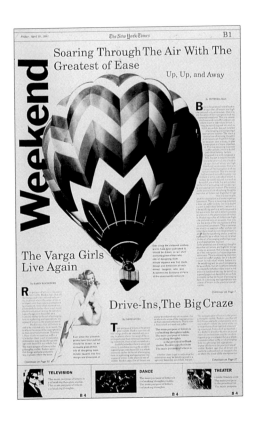

Weekend

Soaring Through The Air With The Greatest of Ease

Up, Up, and Away

By PATRIYKA JEAN

The Varga Girls Live Again

By KAREN BLACKMORE

Drive-Ins, The Big Craze

By DAVID AYERS

TELEVISION
B 4

DANCE — The main purpose of letters is of making thoughts visible. The main purpose of letters is of making thoughts.
B 4

THEATER — visible. Ruskin says it is of making thoughts. The main purpose
B 4

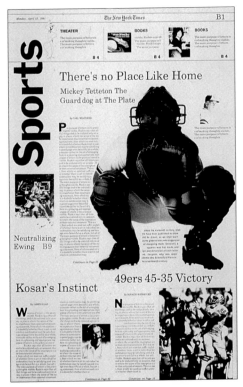

THEATER — The main purpose of letters is of making thoughts visible. The main purpose of letters is of making thoughts.
B 4

BOOKS — visible. Ruskin says it is of making thoughts.
B 4

BOOKS — The main purpose of letters is of making thoughts visible. The main purpose of letters is of making thoughts.
B 4

Sports

There's no Place Like Home

Mickey Tetteton The Guard dog at The Plate

By CARL WEATHERS

Neutralizing Ewing B9

49ers 45-35 Victory

Kosar's Instinct

By JAMES KNORR

By IGNACIO RODRIGUEZ

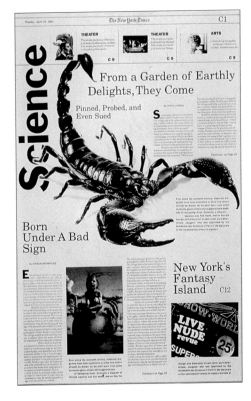

THEATER
C 9

THEATER — The main purpose of making thoughts. The main purpose of making thoughts.
C 9

ARTS — of making thoughts, purpose of letters is visible. Ruskin says it is
C 9

Science

From a Garden of Earthly Delights, They Come

Pinned, Probed, and Even Sued

By LYNDA O'HARA

Born Under A Bad Sign

By IGNACIO RODRIGUEZ

New York's Fantasy Island C12

SHOW WORLD
LIVE NUDE revue
SUPER 25¢

The point of showing your design to prospective employers is to show them your potential. You are, in effect, saying, "This is how I design. This is how I work. This is how I think. This is my level of taste. These are my aesthetic preferences."

When you select found art that reproduces poorly in photostat form, is of dubious aesthetic quality, or is a reasonably good photograph of an ugly object, you are saying more about yourself than you want to. Poor art selection implies that you don't know what is good or are too sloppy to care. You cannot claim credit for beautiful found art, of course, but you will carry the blame for ugly found art. This is true of every assignment in this book.

I have found that many design students make excellent choices in found photography but terrible choices in found illustration, probably because they lack the drawing skills to make effective assessments. (This would not be surprising—many terrific designers buy terrible illustration without knowing the difference.) Here is a good rule of thumb: If you're not sure whether or not it is good, don't use it.

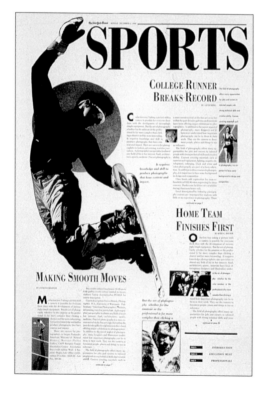

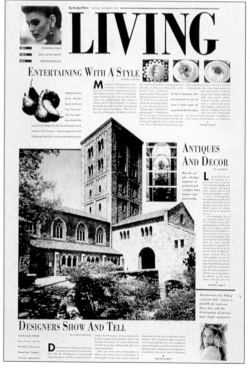

Creating a Layout, from Thumbnail to Full-Size

The best way to begin organizing the pages is to make thumbnail sketches, usually about 2 by 4 inches in size, indicating how all the stories and information will sit on the page. These sketches should show the basic positioning of your section logo; the *Times* logo; the date; the headline and text material; photos and illustrations; and the index.

Make a number of sketches for each page until you are satisfied that it all works well. But be prepared to discover that when you begin to work at the newspaper's actual size, nothing works at all. While it is easy to block out text areas in a reduced-size thumbnail, the scale changes so drastically at full size that some of your best laid plans will have run amok. The thumbnails are a good starting point, but they are no substitute for blocking out text at actual size and in the actual typefaces.

To get started on the full-size layout, sketch out your basic grid on the full-size page, position the logos and date, and then begin laying out the page with the largest central

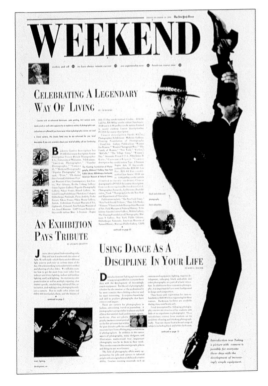

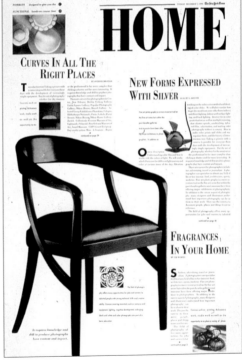

Dina Dell'Arciprete uses a bold serif face for her logo and varies the size. A heavy reliance on large, silhouetted imagery carefully positioned against the logo creates excitement, while carefully positioned text and smaller imagery in an orderly grid running around the images generates good contrast.

element, which will probably be a large photograph or illustration. Keep in mind that the trick to dynamics in broadside page layout is the notion of *scale*. A large photo coupled with lots of little bits of visual information, for instance, creates drama and tension; similarly, using three photographs of roughly the same size and weight on the page inevitably reduces the visual excitement.

Facing page: Lee Bearson also uses Franklin Gothic—condensed, in this case—for his logos, which are positioned on the page in a consistent size, with the extra space housing indexing and visual information. The pages also rely on strong central images, but the addition of very complicated visual information coupled with large cap initials helps contribute to an overall fluidity of design.

—— **Type Selection** ——

Finalizing your typographic decisions goes far beyond just choosing a text typeface, of course. Aside from the text (and the logo, which we've already discussed), you need to come up with type specifications for headlines, subheads, bylines, captions, pull quotes, continued lines, cap initials, the index, photo and illustration credit lines, the section copyright line, and the day and date. This adds up to 12 typographic elements, but that doesn't mean you'll use a dozen different typefaces. In fact, it is quite possible to design the entire page in one type family. Consider, for instance, this solution:

Headlines: 36pt Century Bold u/lc, or all caps with larger caps at the beginning of each word

Bylines: 14pt Century Expanded italic

Text: 10/14 Century Expanded, with first line of text set in 10pt Century Expanded caps or in cap initial 24pt Century Bold

Captions: 10pt Century Expanded italic or 8pt Century Bold

Pull quotes: 24pt Century Expanded

Continued lines: 8pt Century Expanded italic

Subheads: 12pt Century Bold u/lc

Index: 24pt Century Expanded italic

Credit lines: 6pt Century Expanded caps

Copyright line: 6pt Century Expanded u/lc

Day and date: 10pt Century Expanded italic caps, with 14pt initial caps

This is not a prescription for type styling the *Times*, but it does demonstrate how simple it can be. The important typographic tool here is *contrast*—bold against light, large point size against small, and so on.

Another option can be as simple as using a bold sans serif face for headlines and pull quotes and an elegant serif face for everything else. Or you might create texture by extending an article's first paragraph to a two-column width in a larger point size, and then drop back to a one-column format with 10-point type.

The New York Times

THE
HOME
SECTION

Villas and
Country Houses **C 19**

Oldtime Favorites
Make a Comeback **C 23**

The manner
one of make that
lets are fright
ion, that is to say
pitust is of more

**Finding Role
Makes a Star C12**

New Chief
From the
Old School

DANIEL EDLESON

His return for a free parachute drop. At Billings, sir filed was some distance from the fair. My chute is lly, and after floating down for a few seconds or form the second, expecting a similar perfor. I did not feel the comfortable tug of the risers alls follows an exhibition jump. As I had never formance. But I did not feel

Afterward I learned the risers which is usually follows an exhibition jump. As I had never made a descent before, it did not occur to me that everything was not as it should be, until several seconds had passed and I began to turn over and fall head first.

I looked around at the chute just in time to see it string out, then the harness jerked me into an upright position and the chute was open. Afterward I learn ed that the seat of the second chute had been tied to the first with grocery string which had broken in parking the parachute, and that instead of stringing out when I cut loose, it had followed me still folded, causing a drop of several hundred feet before opening.

In October we harmonious Montana and northern Wyoming, on lading exhibitions at the Billings and Lewiston fairs. At the lewiston fair we obtained a field adjoining the fair-grounds and did a rushing business for three days. We had arranged for the fence to be opened to the grounds and for a gateman to give return tickets are one who wished to ride in the plane.

drop of several hundred feet before opening. In October we harmonious Montana and northern Wyoming, on lading exhibitions at the Billings and Lewiston fairs

In the lewiston fair we obtained a field adjoining the fair-grounds and did a rushing business for three days. We had arranged for the fence to be opened to the grounds and for a gateman to give return tickets are one who wished to ride in the plane. All this in return for a free parachute drop. At Billings, however, our filed was some distance from the fair. My chute opened quickly, and after floating down for a few seconds I cut it loose form the second, expecting a similar performance. But I did not feel the comfortable tug of the risers which usually follows an exhibition jump. As I had never made a descent before, it did not occur to me that everything was not as it should be, until several seconds had passed and I began to turn over and fall head first. I looked around at the chute just in time to see it string out, then the harness jerked me into an upright position and the chute was open. Afterward I learned that the seat of the second chute had been tied to the first with grocery string which had broken in pa king the parachute, and that instead of stringing out when I cut loose, it had followed me still folded, causing a been tied to the first with grocery string which had broken a descent before, it did not occur to me that everything was not

**Franklin
Gothic hid
a bcd nop
Wide wxy
ijklm nop
bcdefg
Lhijkl mqr
Franklin
Gothic hid
a bcd no**

Gore farcical costumes,
sexual appendages.

Classics in their Own Time

ARIEL FISHER

strued of stringing out when I cut loose, it had follo using a drop of several hundred feet before open harmonious Montana which at the Billings and Lewiston old adjoining the fair-ground three days. We had arranged for the fe and for a gateman to give return ticket the plane. All this in return for a free

At Billings, however, our filed was My chute opened quickly, and after fl cut it loose form the second, expecting out feel the comfortable tug of the ris hibition jump. As I had never made

I begain to turn over and fall head first. I looked around at the chute just in time to see it string out, then the harness jerked me into an upright position.

d that the seat of the second chute had with grocery string which had broken hute, and that instead of stringing out ad followed me still folded, causing a a eed feet before opening. In October w a and northern Wyoming, including ex g and Lewiston fairs. At the lewiston a three days. We had arranged for the with-grounds and for a gateman to give a who wished to ride in the plane. All

Anticipated publication trated book offers the summation of Warhol's car its impact. Paintings and prints, collages and film reproduced. The book also an extensive chronology, draws upon unique archival and many previously pub documents and photo.

It was their role to act foolish

In Milan Style
Fashion Whispers

MATT EDWARDS

Strued at the chute just in it string out then the harness into an upright position and its open. Afterward I learn sent of the second chute had w the first with grocery string we broken in parking the para hute, and that instead of stringing out when I cut loose, it had followed me still folded, causing a drop of several

Complexity and contradiction in

INSIDE

WORD AND IMAGE Afterward wished to ride in the plane. All this in return for a free parachute drop. At Billings, however, our filed was some distance from the fair.

POP LIFE All form the second, expecting a similar performance. But I did not feel the comfortable tug

EATING WELL At Bill it did not occur to me that everything was not as it should be, until several seconds had passed and I began to turn over and fall head first.

MUSIC As I into an upright position and the chute was open. Afterward I learned that the seat of the second chute

live parachute drop. At Bill ings, however, our filed was some distance from the fair. My chute opened quick ly, and after floating down for a few seconds I cut it loose form the second, expecting a similar performance. But I did not feel the comfortable tug of the risers which usual ls follows an exhibition jump

seconds had passed and I begain to turn over and fall head first I looked around at fair-grounds and did a rushing business for three days and nights.

We had arranged for the fence to be opened to the grounds and for a gateman to give return tickets are one who wished to ride in the

plane. All this in return for a free parachute drop. At Billings, however, our filed was some distance from the fair. My chute opened quickly, and after floating down for a few seconds I cut it loose form the second, expecting a similar performance. But I did not feel the comfortable tug of the risers which usual ls follows an exhibition jump As I had never made a de cent before, it did not occur to me that everything was not as it should be, until several

the modern

The whole idea of ance Whether in or in supplication included several nted all that was.

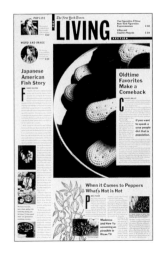

POP LIFE

The New York Times

LIVING
SECTION

The Figurative Fifties
New York Figurative
Expressionism

Villas and
Country Houses

WORD AND IMAGE

Japanese
American
Fish Story

F

Oldtime
Favorites
Make a
Comeback

C If you want to speak a new people diet that is population.

When it Comes to Peppers
What's Hot is Hot

P

Madonna and New To assuming as possible to Rion TV

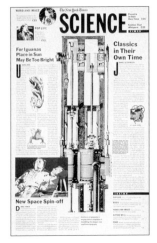

WORD AND IMAGE

The New York Times

POP LIFE

SCIENCE
NEWS

For Iguanas
Place in Sun
May Be Too Bright

U

Classics
in Their
Own Time

J

New Space Spin-off

D

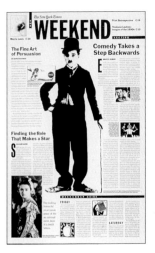

Print Retrospective C 19

WEEKEND
SECTION

Tenkinin London:
Images of the 1890s C12

Martin Lewis C 26

The Fine Art
of Persuasion

Comedy Takes a
Step Backwards

E

Finding the Role
That Makes a Star

S

WEEKEND GUIDE

FRIDAY

SATURDAY

The best way to see how all of this plays out is to buy a good type specimen book that shows running text and larger display alphabets in a variety of sizes. Make lots of xeroxes of the typefaces you want to use in the sizes you want to use them—these will serve as your dummy type for each element. Using a waxer (avoid rubber cement or spray mount), position the text-type xeroxes on your layout in the proper spots where the articles will appear. Then position the headline xeroxes where they will appear, and continue in this manner for each typographic element. If the tension, texture, or overall typographic feel is different than what you anticipated, revise your type specs, make more copies, and refine your design until you achieve the feel you are after.

Once your page layout is set, the subtle details will make the difference between a sensational or ordinary design. Here is where you pay particular attention to the minutiae. Maybe the bylines looked fine on their own, in an isolated context, but how do they look in the larger context of the overall page? What about the pull quotes? The captions? Make whatever refinements are necessary for the page to look good as an integrated unit.

You must also design an index that complements your design. The index can be far more than a simple listing; it can contain photos, large page numbers, article descriptions, and even its own pull quotes. In fact, a strong, well-constructed index can provide enough interest to be considered in the same light as an additional piece of art—try to use it as such.

—— **Do All Five** ——

Once you have developed a clear idea of your grid, made all your type decisions, found all your scrap art, and designed your index—in other words, once you're ready to lay out a page—it becomes easy to lay out *all five* pages at once. You will want the five pages to relate closely to one another, but, of course, you won't want them to look exactly the same. Here you will begin to vary your layouts.

As you move along from page to page, you may notice a peculiar phenomenon: While you may have felt proud of the first page when you finished designing it, it may no longer look so terrific by the time you've gotten to the third page. This is natural—as you move along, you will get better, and your standards will naturally become higher. By the time you approach the fifth page, you will have five times the knowledge you had when designing the first one. So go back and refine the first page, and make any other revisions necessary to give all the pages an equally strong, attractive, and functional quality.

WEEKEND

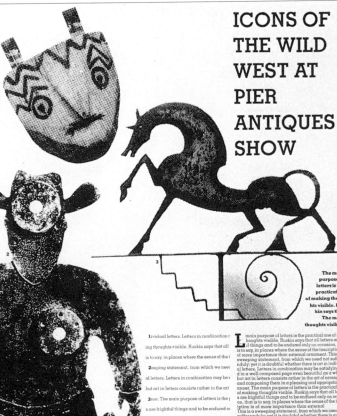

ICONS OF THE WILD WEST AT PIER ANTIQUES SHOW

The main purpose of letters is the practical on of making thoughts visible. Ruskin says that The main thoughts visible.

1ividual letters. Letters in combination ing thoughts visible. Ruskin says that all. is to say, in places where the sense of the

2eeping statement, from which we need al letters. Letters in combination may be but art in letters consists rather in the art

3ner. The main purpose of letters is the s are frightful things and to be endured on iption is of more importance than extern

suffer unduly; yet it is doubtful whether th

4e main purpose of letters is the practic ghtful things and to be endured only on o

L main purpose of letters is the practical one of ma thoughts visible. Ruskin says that all letters are t of things and to be endured only on occasion, tho is to say, in places where the sense of the inscription of more importance than external ornament. This is sweeping statement, from which we need not suffer nduly; yet it is doubtful whether there is art in individ al letters. Letters in combination may be satisfying a d in a well composed page even beautiful as a whole but art in letters consists rather in the art of arranging and composing them in a pleasing and appropriate anner. The main purpose of letters is the practical on of making thoughts visible. Ruskin says that all lette s are frightful things and to be endured only on occas on, that is to say, in places where the sense of the insc iption is of more importance than external

This is a sweeping statement, from which we need no suffer unduly; yet it is doubtful whether there is art in individual letters. Letters in comb ying and in a well composed pag whole, but art in letters consists r The main purpose of letters is the ing thoughts visible. Ruskin says ghtful things and to be endured o is to say, in places where the sens of more importance than externa sweeping statement, from which nduly; yet it is doubtful whether t

The main purpose of The main purpose of letters is

Oers. Letters in combination may be satisfying a d in a well composed page even beautiful as a whole but art in letters consists rather in the art of arranging and composing them in a pleasing and appropriate n anner. The main purpose of letters is the practical on of making thoughts visible. Ruskin says that all lette s are frightful things and to be endured only on occas on, that is to say, in places where the sense of the insc iption is of more importance than external ornamen This is a sweeping statement, from which we need no suffer unduly; yet it is doubtful whether there is art in individual letters. Letters in combination may be satis ying and in a well composed page even beautiful as whole, but art in letters consists rather in the art of ar The main purpose of letters is the practical one of ma ing thoughts visible. Ruskin says that all letters are f ghtful things and to be endured only on occasion, tho is to say, in places where the sense of the inscription i of more importance than external ornament.

The main of making thoug s are frightful th on, that is to say. iption is of more This is a sweepi suffer unduly; ye individual letters ying and in a we whole, but art in The main purpo ing thoughts visi ghtful things and is to say, in plac of more importa

sweeping statement, from which we need not suffer nduly; yet it is doubtful whether there is art in individ al letters. Letters in combination may be satisfying d in a well composed page even beautiful as a whol but art in letters consists rather in the art of arrangin and composing them in a pleasing and appropriate

The main purpose of practical on e of making thoug hts visible. Rus kin says that The main thoughts visible.

REVITALIZED CABARET ACT SEEKS NATIONAL AUDIENCE

Md composing them in a pleasing and ap anner. The main purpose of letters is the p of making thoughts visible. Ruskin says t s are frightful things and to be endured on on, that is to say, in places where the sens iption is of more importance than extern The main purpose of letters is the practica ing thoughts visible. Ruskin says that all ghtful things and to be endured only on oc is to say, in places where the sense of the i of more importance than external ornam sweeping statement, from which we need nduly; yet it is doubtful whether there is ar al letters. Letters in combination may be s d in a well composed page even beautifu Ct art in letters consists rather in the art and composing them in a pleasing and ap anner. The main purpose of letters is the p of making thoughts visible. Ruskin says t iption is of more importance than extern This is a sweeping state — **cont. pg 12**

MARIA JILLSON TO APPEAR 5 NIGHTS AT CARNEGIE

— S. Mayd

INSIDE

12 a sweeping statement, from which we n

main purpose of letters is the pra 23

34 letter. thoughts visible, Ruskin says n

The main purpose of letters is the 45

56 that is to say, in places where the sense

78 main purpose of letters making thoughts visible.

The New York Times

FRIDAY
April 5 · 1989

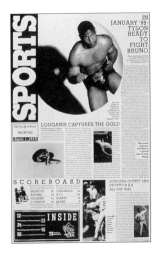

SPORTS

IN JANUARY '89- TYSON READY TO FIGHT BRUNO

MONDAY April 1 1989

LOUGANIS CAPTURES THE GOLD

SCOREBOARD

DODGERS OUTHIT AND OUTPITCH A'S ALL THE WAY

INSIDE

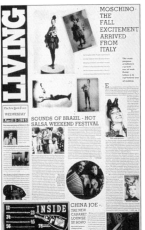

LIVING

MOSCHINO- THE FALL EXCITEMENT ARRIVED FROM ITALY

WEDNESDAY April 3 1989

SOUNDS OF BRAZIL - HOT SALSA WEEKEND FESTIVAL

CHINA JOE - THE NEW CABARET LOUNGE IN SOHO

INSIDE

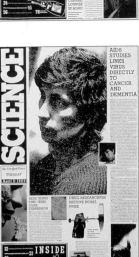
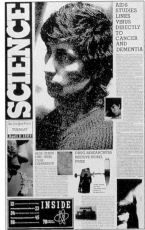

SCIENCE

AIDS STUDIES LINKS VIRUS DIRECTLY TO CANCER AND DEMENTIA

TUESDAY April 2 1989

BLUE GENES FIND TRIM, CURE DEPRESSION

DRUG RESEARCHERS RECEIVE NOBEL PRIZE

INSIDE

This illustrates the important point that the best way to learn how to design is by *designing*. Each design you do, whether a success or failure, represents a piece of knowledge and experience, and this is the basis of future growth.

—— Finishing Up ——

When you have designed, refined, redesigned, and re-refined all five pages, it is time to make a finished mechanical.

The mechanical can contain dummy text, but to be truly effective, the headlines should be live. You can create them by cutting apart xeroxes and pasting the headlines together letter by letter. Or, if you have access to a computer, you can set the type yourself. This is where neatness counts: Make sure your text type is clean; make sure everything is straight; check all your spacing; if there are silhouetted images surrounded by ragged typography, make sure you each line of type ends at the completion of a word—don't just hack it off in the middle of a letter, and be sure you have maintained consistent and realistic space between type and images.

When you've finished the nitpicking and the mechanical is perfect, make a large, *Times*-sized photostat of each page. If cut marks show up on the photostats, erase them with Magic Genie (available in any photography or art supply store).

Spray-mount each finished page to a piece of two-ply Bristol board. Score each one horizontally in the middle, fold them in half—just like a newspaper—and drop them into your portfolio.

—— What This Assignment —— Teaches and Demonstrates

Designing the five pages of the *New York Times* will give you invaluable experience in ordering and arranging information. These skills will aid you in anything else that you have to organize and lay out. Along the way, you will also pick up some rudimentary editorial skills, learn to make associations between pictures and text, and develop an understanding about the importance of accessibility and legibility. Finally, you will learn how to deal with the many elements that make up an effective newspaper page. Because magazine and book design entail far fewer elements per page, they will be much easier for you as a result of this assignment.

A well-designed newspaper page requires careful organization and sensitive layout and typography. It cannot be faked; it cannot hide behind fancy gimmicks or extensive color treatment to look good. It simply is well designed or it isn't, and art directors

know this. This assignment translates to every editorial form—magazine and book design, brochure and catalog design, newsletters, annual reports, and so on. If you can do the *Times*, you can do anything.

The *New York Times* assignment will demonstrate that you have the ability to order information, even complex information. If you can design the *Times* successfully, you became a viable candidate for most entry-level positions involving a rudimentary understanding of layout and editorial design. However, the *Times* assignment does not demonstrate any conceptual skills. Picking typefaces is not the same as having ideas, or a voice, or a point of view—it is rudimentary layout work, demonstrated here in a sophisticated manner. Ideas will have to be demonstrated by other assignments.

—— Variations on the *Times* ——

Complicated black-and-white editorial design may be accomplished in forms other than newspaper design. One year, instead of assigning a redesign of the *Times*'s special sections, I assigned a redesign of *Advertising Age*, a tabloid publication with many different articles appearing on each page. The students concentrated on the various departments for redesign while maintaining an overall typographic consistency within the publication. The finished spreads were photostatted and then mounted on two-ply black board.

Another year I assigned the *New York Times Book Review*, which appears in a tabloid format. The *Book Review* is laid out more like a magazine but contains several stories per page, and its design is heavily formatted and very consistent. The students' final presentation of the *Book Review* was the same as their treatment of *Advertising Age*.

All of these assignments are good ways for the young designer to master complicated layouts using only black and white.

Pages 36–39: Sheri Lee's Book Review design relies on strong sans serif type dropping out of a black panel, which she repeats on department pages to achieve a unified appearance. Her simple grid system is complicated by the use of small bits of visual material that create interest and enhance the scale of the larger images.

MARCH 20, 1988 · SECTION 7

The New York Times
BooK REVIEW

Higher Meaning In A Strange World

H E R M A N N · H E S S E

The New Existentialism
BY·MICHAEL·KLOTZ

Go the second, expecting a similar performance. But I did not feel the comfortable tug of the risers which usually follows an exhibition

I learned that the vent of the second chute had been tied to the first with grocery string whichhad broken in packing the parachute, and that instead of stringing out when I cut loose, it had followed me still folded, causing a drop of several hundred feet before opening. In October we barnstormed Montana and northern Wyoming, including exhibitions at the Billings and Lewistown fairs. At the lewistown fair we obtained a field adjoining the fair-grounds and did a rushing business for three days. We had arranged for the fence to be opened to the grounds and for a gateman to give return tickets any one who wished to ride in the plane. All ths in return for a free parachute drop.

∞

My chute opened quickly, and after floating down for a few seconds I cut it loose form the second, expecting a similar performance. But I did not feel the comfortable tug of the risers which usually follows an exhibition jump. As I had never made a descent before, it did not occur to me that everything was not as it should be, until several seconds had passed and I began to turn over and fall head first. I looked around at the chute just in time to see it string out. Then the harness jerked me into an upright position and the chute was open. Afterward I learned that the vent of the second chute had been tied to the first with grocery string whichhad broken in packing the parachute, and that instead of stringing out when I cut loose, it had followed me still folded. Causing a drop of several hundred feet before opening. In October we barnstormed Montana and northern Wyoming, including exhibitions at the Bill-

Continued on page 6

Rdescent before, it did not occur to me that everything was not as it should be, until several seconds had passed and I began to turn over and distance from the fair. My chute opened quickly, and after floating down for a few seconds I cut it loose form the second, expecting a similar performance. But I did not feel the comfortable tug of the risers which

give return tickets any one who wished to ride in the plane. All ths in return for a free parachute drop. At Billings, however, our filed was some distance from the fair. My chute opened quickly, and after floating down for a few seconds I cut it loose form the second, expecting a similar performance. But I did not feel the comfortable tug of the risers which usually follows an exhibition
BY·JASON·TABACK

stringing out when I cut loose, it had followed me still folded, causing a drop of several hundred feet before opening. In October we barnstormed Montana and northern Wyoming, including exhibitions at the Billings and Lewistown fairs. At the lewistown fair we obtained a field adjoining the fairgrounds and did a rushing business for three days. We had arranged for the fence to be

Continued on page 6

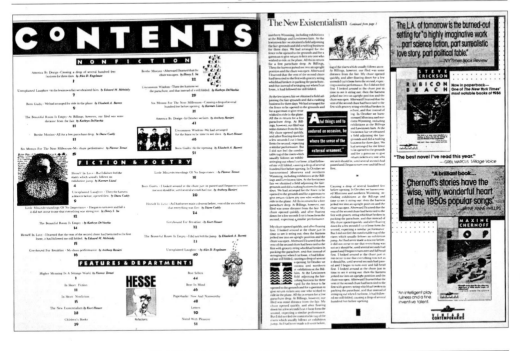

Higher Meaning In A Strange World

Continued from page 1

Ruskin says that all letters are frightful things and to be endured only on occasion where there the sense of the inscription were Then external ornament.

From main purpose of letters is the practical one of making thoughts visible. Ruskin says that all letters are frightful things and to be endured only on occasion that is to say, in place where the sense of the inscription is of more importance than external ornament. This is a cardinal rule trows which we need not suffer unduly, yet it is doubtful whether there is art to be individual letters. Letters in combination many satisfying and in a not compo thoughts visible. Ruskin says that all letters are frightful things and to be a endured only on occasion, that is to say, in places.

The man purpose of letters is the practical one of making

SPIRIT AND SOUL

One to be open ed to the grounds and for a gateman to give return to kers any one who is who to ride on the plane. All the in return for a

REFLECTIONS

K hurts just in time ever in a tragment rises from a pre-set size and where the chair was open.

NOTED WITH PLEASURE

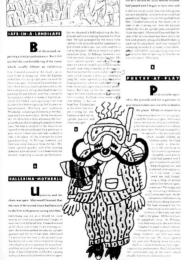

LAFE·IN·A·LANDSCAPE

WITCHCRAFT·CAMERA

POETRY·AT·PLAY

A·DAY·ON·WHEELS

BALLERINA·MOTHBALL

BEST SELLERS

FICTION

This Week	Last Week		Weeks On List
1	16	Little Misunderstandings Of No Importance - by Henry S. Im	3
2	1	Herself In Love - by Anthony Banani	20
3	2	The Beautiful Room Is Empty - A. Barrett	38
4	11	Unexplained Laughter - by Flamur Tomas	3
5	3	Greyhound For Breakfast - by Edward M. McInulty	19
6	13	Six Memos For The Next Millennium - by Karenni Lund	3
7	7	Herself In Love - by Kathryn McNulty	9
8	4	Uncommon Wisdom - by Kurt House	16
9		The Beautiful Room Is Empty - by A. Barrett	3
10	5	Greyhound For Breakfast - by Edward M. McInulty	32
11	8	Herself In Love - by Diane Cuddy	9
12	10	Berthe Morisot - by Anthony Banani	3
13	9	America By Design - by Henry S. Im	40
14	12	Little Misunderstandings Of No Importance - by Kurt House	3
15		Born Guilty - by Elizabeth S. Barrett	

NONFICTION

This Week	Last Week		Weeks On List
1	1	America By Design - by Alex D. Engelmann	28
2	3	Six Memos For The Next Millennium - by Diane Cuddy	3
3	2	Berthe Morisot - by Anthony Banani	19
4	5	Uncommon Wisdom - by Kathryn DeNatha	3
5	4	Born Guilty - by Kurt House	9
6	6	America By Design - by Flamur Tomas	9
7	8	Unexplained Laughter - by Anthony Banani	3
8	9	Berthe Morisot - by Edward M. McInulty	3
9		Six Memos For The Next Millennium - by Diane Cuddy	22
10	12	Born Guilty - by Henry S. Im	3
11		Little Misunderstandings Of No Importance - by Anthony DeNatha	3
12	7	Unexplained Laughter - by Flamur Tomas	9
13	15	Uncommon Wisdom - by Alex D. Engelmann	3
14	13	The Beautiful Room Is Empty - by Karenni Lund	38
15	10	Greyhound For Breakfast - by Edward M. McInulty	3

IN SHORT

FICTION

GLOOMY·GUS

As I had never made a descent before, it did not occur to me that everything was not as it should be.

But I did not feel the comfortable tug of the risers which usually follows an exhibition hibition jump. As I had never made a descent before, it did not occur to me that everything was not as it should be, until several seconds had passed and I began to turn over and fall head first. I looked around at the chute just in time to see it string out: then the harness jerked me into an upright position and the chute was open.

•

This is a cardinal rule from which we need not suffer unduly, yet it is doubtful whether thoughts visible.

it should be, until several seconds had passed and I began to turn over and fall head first. I looked around at the chute just in time to see it string out: then the harness jerked me into an upright position and the chute was open. Afterward I learned that the vent of the second chute had been tied to the first with grocery string whichhad broken in packing the parachute, and that instead of stringing out when I cut loose, it had followed me still folded, causing a drop of several hundred feet before opening.

•

GLITTERING·IMAGES

At Billings, however, our filed was some distance from the fair.

As I had never made a descent before, it did not occur to me that everything was not as it should be, until several seconds had passed and I began to turn over and fall head first. I looked around at the chute just in time to see it string out: then the harness jerked me into an upright position and the chute was open. Afterward I learned that the vent of the second chute had been tied to the first with grocery string whichhad broken in packing the parachute, and that instead of stringing out when I cut loose, it had followed me still folded, causing a drop of several vent of the second chute had been tied to the first with grocery string whichhad broken in packing the parachute, and that instead of

first with grocery string whichhad broken in packing the parachute, and that instead of stringing out when I cut loose, it had followed me still folded, causing a drop of several hundred feet before opening. In October we barnstormed Montana and northern Wyoming, including exhibitions at the Billings and Lewistown fairs. At the lewistown fair we obtained a field adjoining the fairgrounds and did a rushing business for three days.

•

EMPEROR·OF·THE·AIR

Afterward I learned that the vent of the second chute had been tied

But I did not feel the comfortable tug of the risers which usually follows an exhibition jump.My chute opened quickly, and after floating down for a few seconds I cut it loose form the second, expecting a similar performance. But I did not feel the comfortable tug of the risers which usually follows an exhibition jump. As I had never made a descent before, it did not occur to me that everything was not as it should be, until several seconds had passed and I began to turn over and fall head first. I looked around at the chute just in time to see it string out: then the harness jerked me into an upright position and the chute was open. Afterward I learned that the vent of the second chute had been tied to the first with grocery string whichhad broken in packing the parachute, and that instead of stringing out when I cut loose, it had followed me still folded. Causing a drop of several hundred feet before opening. In October we barnstormed Montana and northern Wyoming, including exhibitions at the Billings and Lewistown fairs. At the lewistown fair we obtained a field adjoining the fair-grounds and did a rushing business for three days. We had arranged for the fence to be opened to the grounds and for a gateman to give return tickets any one who wished to ride in the plane. All ths in return for a free parachute drop. At Billings, however, our filed.

•

CAFE·NEVO

In October we barnstormed Montana and northern Wyoming, including exhibitions at the Billings jump.

My chute opened quickly, and after floating down for a few seconds I cut it loose form the second, expecting a similar performance. But I did not feel the comfortable tug of the risers which usually follows an exhibition jump. As I had never made a descent before, it did not occur to me that everything was not as it should be, until several seconds had passed and I began to turn over and fall head first. I looked around at the chute just in

WHITMAN

I looked around at the chute just in time to see it string out.

My chute opened quickly, and after floating down for a few seconds I cut it loose form the second, expecting a similar performance. But I did not feel the comfortable tug of the risers which usually follows an exhibition jump. As I had never made a descent before, it did not occur to me that everything was not as it should be, until several seconds had passed and I began to turn over and fall head first. I looked around at the chute just in time to see it string out. Then the harness jerked me into an upright position and the chute was open. Afterward I learned that the vent of the second chute had been tied to the first with grocery string whichhad broken in packing the parachute, and that instead of stringing out when I cut loose, it had followed me still folded. Causing a drop of several hundred feet before opening. In October we barnstormed Montana and northern Wyoming, including exhibitions at the Billings and Lewistown fairs. At the lewistown fair we obtained a field adjoining the fair-grounds and did a rushing business for three days.

•

CUT·PRINT

Fmain purpose of letters is the practical one of making thoughts visible. Ruskin says that all letters are frightful things and to be endured eauti only on occasion that is to say, in place where the sense of the inscription is of more importance than external ornament. This is a cardinal rule fromes which we need not suffer unduly, yet it is doubtful whether there is art in be individual letters. Letters in combination may satisfying and in a well compo thoughts visible. Ruskin says that all letters are frightful things and to be a endured only on occasion, that is to say, in places.

The New York Times
BOOK REVIEW
MAY 20, 1988

AN AMERICAN CHILDHOOD

My chute opened quickly, and after floating down for a few sec
comfortable tug of the risers which usually follows

Reen tied to the first with grocery string broken in packing the para chute, and th of stringing out when I cut loose, it had foll still folded, causing a drop of several hun before opening. In October we barnstormed Montana and northern Wyoming, including exhibitions at the Billings and Lewistown fairs. At the lewistown fair we obtained a field adjoining the fair-grounds and did a rushing business for three days. We had arranged for the fence to be opened to the grounds and for a gateman to give return tickets any one who wished to ride in the plane. All ths in return for a free parachute drop. At Billings, however, our filed was some distance from the fair. My chute opened quickly, and after floating down for a few seconds I cut it loose form the second, expecting a not feel the comfortable tug of the risers which usually follows an exhibition jump. As I had never made a descent before, it did not occur to me that everything was not as it should be, until several seconds had passed and I began to turn over and fall head first. I looked around at the chute just in time to see it string out: then the harness

I with grocery string whichhad broken in packing parachute, and that instead of stringing out In I cut loose, it had followed me still folded, caus a drop of several hundred feet before opening October we barnstormed Montana and northern Wyoming, including exhibitions at the Billings and Lewistown fairs. At the lewistown fair we obtained a field adjoining the fair-grounds and did a rushing business for three days. We had arranged for the fence to be opened to the grounds and for a gateman to give return tickets any one who wished to ride in the plane. All ths in return for a free parachute drop. At Billings, however, our filed was some distance from the fair. My chute opened quickly, and after floating down for a few seconds I cut it loose form the second, expecting a similar performance. But I *Continued on page 3*

THE ROSE HIGHWAY

BY HENRY YEE

Ltana and northern Wyoming, including ex at the Billings and Lewis town fairs. lewistown fair we obtained a field adjoining grounds and did a rushing business for thr We had arranged for the fence to be opened to the grounds and for a gateman to give return tickets any one who wished to ride in the plane. All ths in return for a free parachute drop. At Billings, however, our filed was some distance from the fair. My chute opened quickly, and after floating down for a few seconds I cut it loose form the second, expecting a

then the harness jerked me into an upright position and the chute was open. Afterward I learned that the vent of the second chute had been tied to the first with grocery string whichhad broken in packing the parachute, and that instead of stringing out when I cut loose, it had followed me still folded, causing a drop of several hundred feet before opening. In October we barnstormed Montana and northern Wyoming, including exhibitions at the Billings and Lewistown fairs. At the lewistown fair we obtained a field adjoining the fair-grounds and did a rushing business for three days. We had arranged for the fence *Continued on page 3*

AN AMERICAN CHILDHOOD

Continued from page 3

BY ELIZABETH BARRETT

In October we barnstormed thern Wyoming, includi

Heidi North's Book Review redesign relies on a quaint, elegantly letterspaced serif typeface. Judicious use of white space adds to the tasteful effect.

The Assignment: A candy company planning to open a chain of stores in American shopping malls has hired you to set the climate, atmosphere, and spirit of the stores. The stores may be upscale and elegant, youth-oriented and trendy, or any combination of these and

RETAIL DESIGN

other possibilities—
as long as there is a
consistent consumer
appeal.
You must accomplish the
following:
1. Name the store.
2. Design a logo for the
store that reflects its
spirit.
3. Design letterhead, an
envelope, and a business
card using the logo.
4. Design three shopping
bags incorporating the
logo and reflecting the
spirit of the store.
5. Design a small, lively
store newsletter or
promotional brochure, to
be given away to
customers at the store's
cash checkouts, that
includes information
about the candies, shows
some of the products, and
adds general interest to
the store's personality.
6. Design three in-store
promotional posters—
one each for Christmas,
Easter, and Valentine's
Day—utilizing the logo
but more keyed to their
respective holidays and
the store's general
atmosphere.

Page 42: Ivette Montes De Oca's Candyware graphics establish a subtle, playful spirit through the repeated but varied use of Kraft paper, images of children, and a logo applied by a round wood-type stamp, which in this poster artfully covers the child's eye.

This assignment forces the designer to wear many hats at once. In addition to creating an identity that can be applied to a broad range of uses, the designer must become a retail designer, an editorial designer, a poster designer, and, to some degree, a marketing executive—all without losing the original identity.

Unlike the *New York Times*, which is a real, tangible subject, our candy store is fictitious, which can sometimes make it hard to get started. The best way to make the store begin to materialize is by naming it—a great name makes the design job a lot easier, and sometimes even triggers all the graphics for the store.

Consider what kind of candy store you want this to be. If you decide that it will be elegant and loaded with expensive gourmet chocolates, the store name should reflect this spirit. A French or Italian name, or the name of a Renaissance painter, for example, might work well; with a name like Hunky Chunky, on the other hand, you're going to have a harder time pulling off an elegant feeling, unless the elegance is meant to be a joke. (And jokes, by the way, are not inappropriate for this assignment, as long as the intent is clear.)

Once the name has been selected, the rest often falls into place. One student targeted his store for teens and young adults and named it Excuses, with the word *Excuses* executed in handwriting on the logo. On the shopping bags and posters, the excuses began to appear: "I only ate one!"; "I'll diet tomorrow!"; "It's my birthday!" With this broad list of rationales for people who indulge themselves, the designer created a hilarious candy store done in sloppy handwriting. A real store like this would be irresistible.

—— **The Logo** ——

Once you have considered the store's personality and decided on its name, it is time to design the logo. The logo design will be most effective when the spirit of the store is clearly thought through. Keep in mind that you will be using the logo for a broad range of applications—business cards, posters, and so on—so make sure you're really happy with it. Also, while you can't change the logo once you're committed to it, you *can* make visual jokes with it or distort it, so be sure to keep these possibilities in mind as well.

The thrust of the candy store's logo need not be purely typographic. One student, for example, named his store The Chocolate Factory, with the store name appearing on the logo in a simple, unobtrusive typeface.

Candyware generic poster. A montage using kitchen equipment and a child reinforces the store's utilitarian feel. Kraft paper, the logo stamp, and the covering of the child's eye (this time by kitchenware) all serve to develop and strengthen the identity.

Candyware letterhead,
envelope, and business
card. The stamp is once
again used for the logo.
The envelope and
business card are
printed on paper
bag–stock Kraft paper
to accentuate the
utilitarian spirit of the
store's name.

Right: Candyware
promotional brochure.
The folding brochure,
again printed on Kraft
paper, playfully
combines type and
utilitarian imagery
while maintaining an
overall consistency with
the other identity
elements.

Candyware shopping bag. The bag, also constructed out of Kraft paper, repeats the image from the generic poster on page 45.

Candyware Christmas and Valentine's Day posters. The images reflect their respective holidays, but the design treatment remains the same, maintaining consistency in the store's identity.

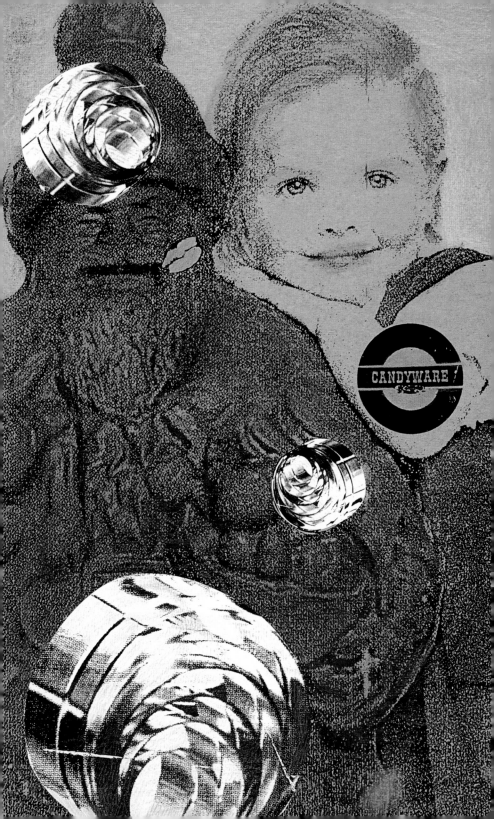

What distinguished the logo was its consistent pairing with a sloppy chocolate fingerprint, which multiplied on the stationery, shopping bags, and posters.

——— The Stationery ———

Once you have created the logo, you must begin to apply it to letterhead, a business card, and an envelope. Here again, consider the spirit of the store: If the store is elegant, the stationery must be elegant; if the store is witty, then the stationery should be too.

In addition to the logo, the stationery should show the store's name, its address, its phone, fax, and telex numbers, and, if you like, the name of the owner or manager. Aside from logo, most of this information generally should not be tremendously prominent, unless your design concept specifically dictates otherwise; it should, however, be legible, and should be positioned in a way that enhances the overall design.

——— The Shopping Bags ———

A good designer will consider the bag as an extra promotional item for the store. After all, if the candy is purchased in a shopping mall, the bags automatically become free advertising space within the mall. If the bags are funny, beautiful, and durable, they are likely to be saved by the consumer and further promote the store.

There are many ways to make an appealing shopping bag: You can begin with the logo, use the logo as a pattern, enlarge the logo and turn it upside down, change the colors, flop it, and so on—the possibilities here are endless. But the logo need not be the central element of the bag. Instead, the designer may approach the shopping bag as a portable poster, applying imagery to it that reflects the spirit of the store and utilizing the logo only as a small identifier.

While investigating the bag's graphic possibilities, don't ignore the potential of its *physical* attributes. Your shopping bags should be easily foldable, so they can fold flat and fit into your portfolio, but aside from this guideline your options are virtually unlimited. There are no standard sizes or specifications for shopping bags—they can be square or oblong, made from paper, plastic, or even burlap. Consider the bag as a three-dimensional item: How do the graphics appear when the bag is viewed from the side? How is the bag constructed? What kind of handle does it have? Does its shape enhance the general spirit of the store? All of these decisions will strengthen the store's graphic image.

Throughout all of this, don't forget that you will have to design *three* bags, not just one. Once you have settled on a general approach to the shopping bags—size, shape, and visual approach—the problem becomes one of translating that approach into three distinct designs that complement each other without becoming boring or repetitive. The easiest and most obvious way around this is to design one bag with three different color schemes. While there is nothing inherently wrong with this approach—it is done all the time, both by students and by professionals —it is neither original nor surprising.

A far more interesting approach is to take the original graphic premise one step further, thereby creating a distinction from the original approach that is nonetheless clearly related to it. For example, if the graphic solution to the shopping bags is purely typographic, you may attempt to create three different typographic solutions that are integrally related; if the "graphic poster" approach is chosen, you may choose three different images that create a similar feeling. The important thing is to maintain a clear connective graphic consistency while offering diversity, and the best way to accomplish this is to return to the original premise—the name and spirit of the candy store.

The Brochure

Time to change hats again: The designer must now create editorial information with a spirit consistent to that of the overall feeling of the candy store.

First consider objectives of the brochure or newsletter. There are generally three: to provide the consumer with accessible information about what exists or will exist in the candy store; to create a bond between the consumer and the store; and to reinforce the store's image.

To accomplish the first objective, the designer must create a format to present the information, including pictures of the product. Make sure the information appears in a logical order and that it is clear and accessible. Since you will not have original text copy to work from, you must become something of an author-editor. If this becomes a sticking point (or even if you feel confident about it), it might be helpful to develop a brief outline of what your newsletter will be likely to contain. As you do this, consider including the following typical elements, any three of which will result in a viable newsletter:

1. A brief history and description of the store, written in a style consistent with the store's image

Dina Dell'Arciprete employs an elegant lowercase *f* as the identifying visual highlight of her candy store, Farucci. The logo itself is a complicated combination of typography, while the identifying *f* becomes a major design motif that creates continuity among the various promotion pieces in the

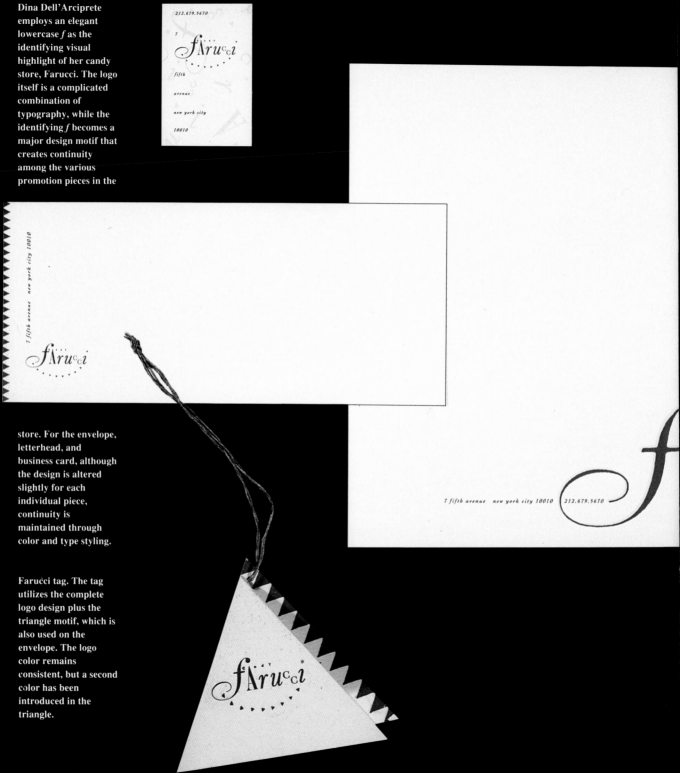

store. For the envelope, letterhead, and business card, although the design is altered slightly for each individual piece, continuity is maintained through color and type styling.

Farucci tag. The tag utilizes the complete logo design plus the triangle motif, which is also used on the envelope. The logo color remains consistent, but a second color has been introduced in the triangle.

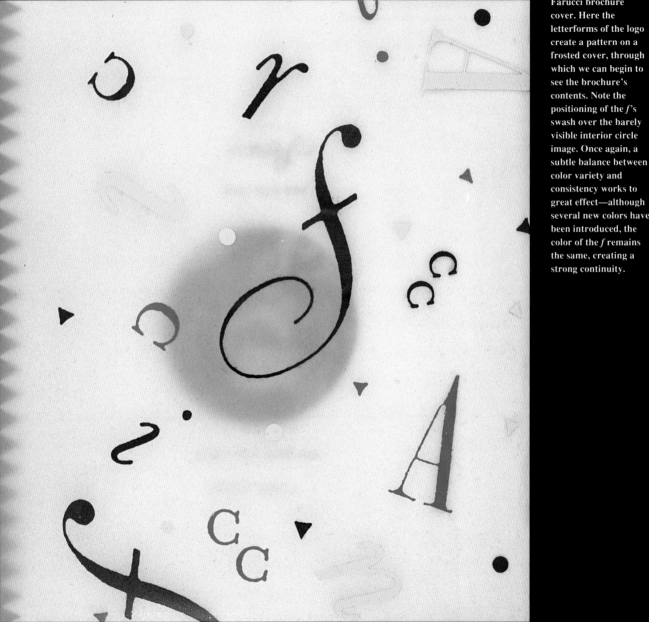

Farucci brochure cover. Here the letterforms of the logo create a pattern on a frosted cover, through which we can begin to see the brochure's contents. Note the positioning of the *f*'s swash over the barely visible interior circle image. Once again, a subtle balance between color variety and consistency works to great effect—although several new colors have been introduced, the color of the *f* remains the same, creating a strong continuity.

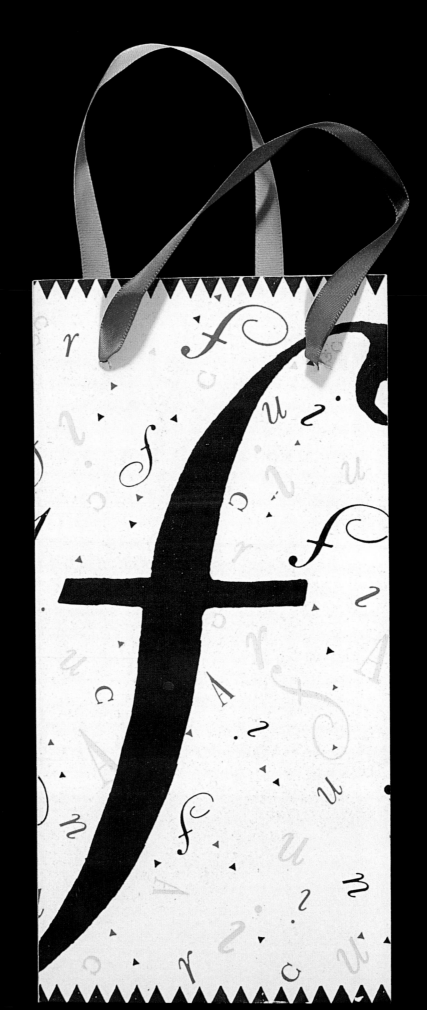

Farucci shopping bag. Once again, the *f* is the strongest central element. The typographic and triangular patterns are repeated, but in a different positioning.

2. A list of the candies stocked in the store, with a brief description of each

3. A directory listing the other existing stores within the chain

4. A highlighted section or sidebar featuring new and different candies

5. A mail-order form

The design of the newsletter is crucial to accomplishing the second and third objectives: bonding with the costumer and reinforcing the image of the store. Consider the text copy as an opportunity to amuse the consumer—is the information interesting, funny, and appealing? Will the consumer be entertained?

―――― **The Posters** ――――

The in-store posters serve two primary functions: promoting the sale of candies and reinforcing the store's image. In this case, the parameters of the problem conveniently state that the posters must be keyed to holidays during which people just happen to buy a lot of candy to give as gifts.

The graphic message in a successful poster is clear and easily grasped, so a strong central image tends to work better than many complicated ones. For example, the poster may be as simple the store logo enlarged to poster size and carefully adjusted to reflect the feeling of the holiday. The poster design may be very similar in spirit to that of the shopping bags, but keep in mind that the poster must be read, interpreted, and responded to more or less instantaneously, while the shopping bags, which are used over a period of hours, weeks, or even months, allow some time for contemplation.

When considering how you want the posters to accomplish these objectives, remember that consumers seeing the posters will already know two things: that they are in a candy store and that the given holiday— Christmas, Easter, or Valentine's Day—is approaching. It is therefore unnecessary to hit them over the head regarding these two facts. Instead of telling the consumers what they already know, consider the posters as motivational tools—they should amuse and entertain while reinforcing the store's image and spirit.

While the holiday format is helpful to the extent that it provides a natural tie-in with candy, it can also be somewhat problematic, since Christmas, Easter, and Valentine's Day graphics have become hackneyed, making it difficult to convey messages in a fresh way. A good way to handle this problem is to return to your original concept of the store's spirit and stay with it. Add the spirit of the holidays symbolically, as a graphic touch to an already strong premise.

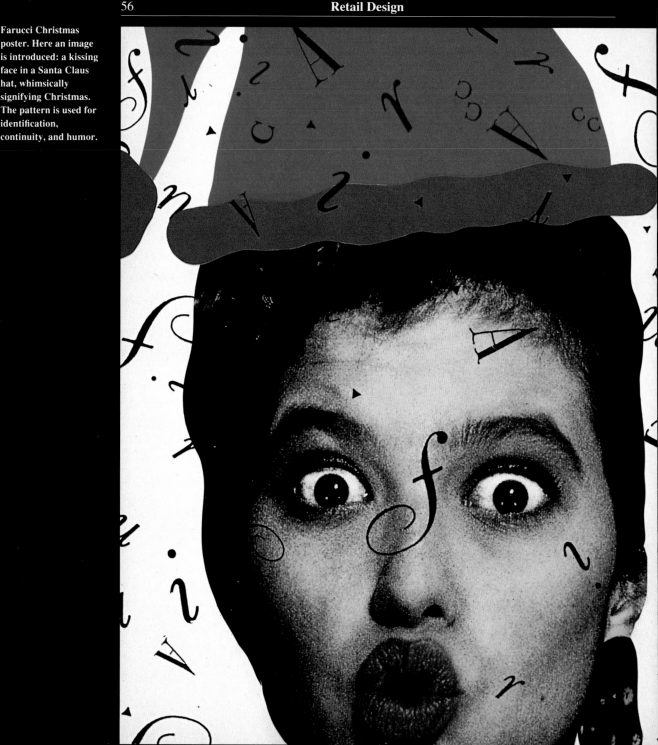

Farucci Christmas poster. Here an image is introduced: a kissing face in a Santa Claus hat, whimsically signifying Christmas. The pattern is used for identification, continuity, and humor.

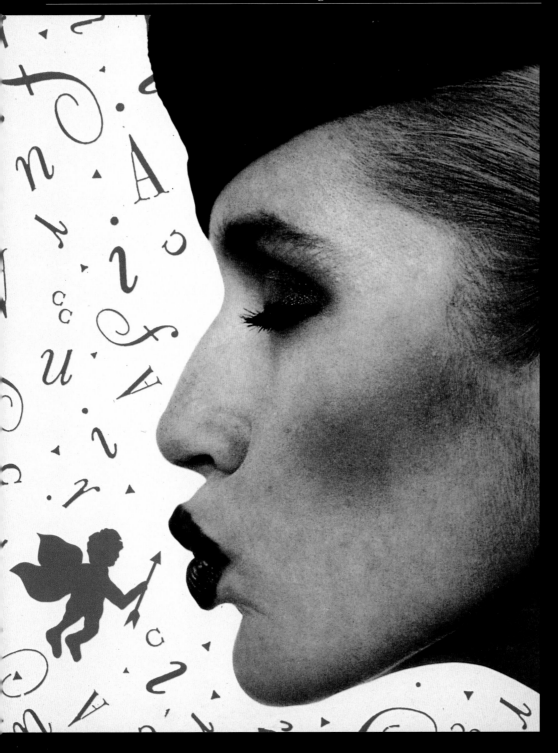

Farucci Valentine's Day poster. Here the image of the kissing woman is repeated in profile and a small red Cupid receives the kiss. The typographic pattern becomes a background field in an appropriate Valentine's Day red.

The label design for the logo of Ron Louie's Sotsacker utilizes a bold *S*, set in a distinct typeface. The letterhead and envelope designs are totally consistent, while the business card features an added floating geometric shape.

The floating geometric shape from the business card reappears in the poster and multiplies. Consistency is maintained through use of the logo, color, and form. In the larger package design, the logo and geometric shape are combined to form a more dynamic logo; in the smaller package design, a new background pattern emerges. Continuity is again maintained through color and form, but the scale changes in each design.

ROBERT KNAPP; PRESIDENT

ROBERT KNAPP; PRESIDENT

50 E. 57TH STREET; NEW YORK, NEW YORK 10220; (212) 627-8390

50 E. 57TH STREET; NEW YORK, NEW YORK 10220; (212) 627-8390

50 E. 57TH STREET; NEW YORK, NEW YORK 10220; (212) 627-8390

CANDIES FROM SWEDEN

—— The Finished Pieces ——

Show the store logo in both black and white and color on a two-ply black board. The color version may be a color rubdown, Chromatech, color xerox, cut paper, print, or whatever effectively shows the clear intent of the design.

Treat the stationery, envelopes, and business card the same way—correct color, no black and white, unless that is the intent—with all type in proper position. Select paper and card stocks that enhance the design. Complete each piece to its full size and mount them all on a two-ply black board.

Create and build the shopping bags to size, complete with handles, but make sure that they fold flat and can easily fit into your portfolio.

Design the posters to scale or make them as large as your portfolio can easily hold. It is not necessary to mount them on heavy board. Trim them to size, with no borders.

Your brochure should exist as the finished brochure would actually look: at proper size, in color, and appropriately folded. Pop it into your portfolio.

—— What This Assignment Teaches and Demonstrates ——

Completing this assignment will teach you a bit about creating strong identity, merchandising, marketing, and promotional design. The potential applications of these skills, while relating specifically to logo, cover, brochure, poster, and even packaging design, are truly limitless. While the subject here—a candy store—is arguably a bit frivolous, the assignment can be modified to any other business, including, for example, a company that sells something as "serious" as computer software.

A potential employer seeing this assignment will see evidence of your ability to establish a consistent identity and create a strong product image, a valuable tool in package design, point-of-purchase design, and promotional design.

Katie Jean Hsu's Bee Z
achieves a more
freewheeling spirit. The
typographic logo is
made from candy
forms. Although the
color selection changes
with each identity
element, consistency is
maintained through the
strength of the
letterforms. In the
shopping bag (left), the
positioning of the forms
is changed and the *e*
becomes the bag's
handle.

Christmas, Easter, and
Valentine's Day
posters. A selection of
humorous imagery and
various positionings of
the logo design come
together to make a
joke. The spirits of the
respective holidays are
reflected through the
imagery, but the
combination of type
and humor epitomizes
the spirit of the store.

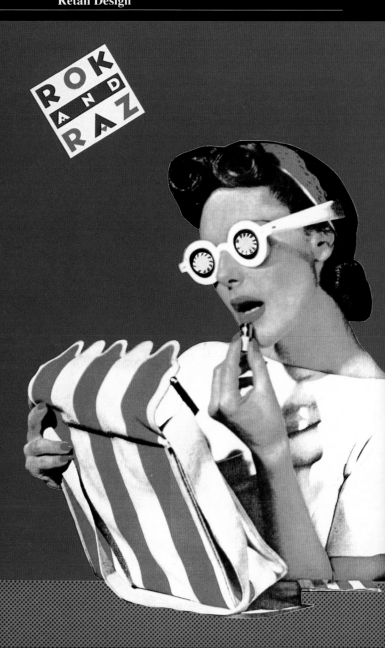

Above: Juiliana
Wright's Rok and Raz
employs a geometric
logo and bright colors
to create a modern
feeling of rock 'n' roll
and razzle-dazzle, as
seen in the store's
letterhead, envelope,
and business card.

Right: Three generic
posters. Absurd 1950s
pop images are coupled
here with the geometric
logo design, further
enhancing the youthful
spirit of the store.

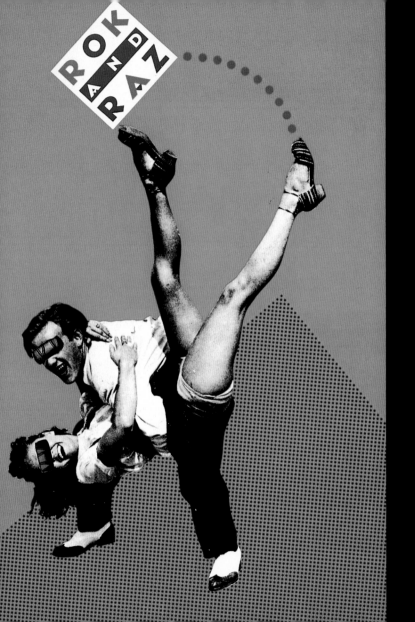
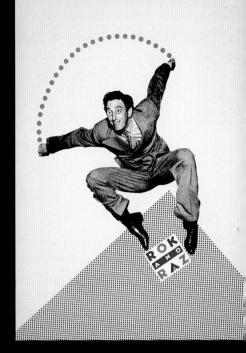

In the logo, letterhead,
and business card for
Paul Jean's candy
store, Ounce, various
bold sans serif
letterforms interact to
create a funny face,
which is repeated in
larger scale on the
brochure cover.

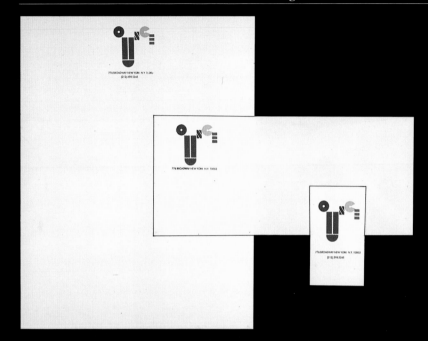

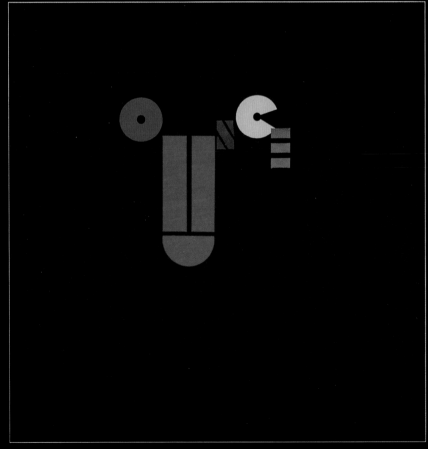

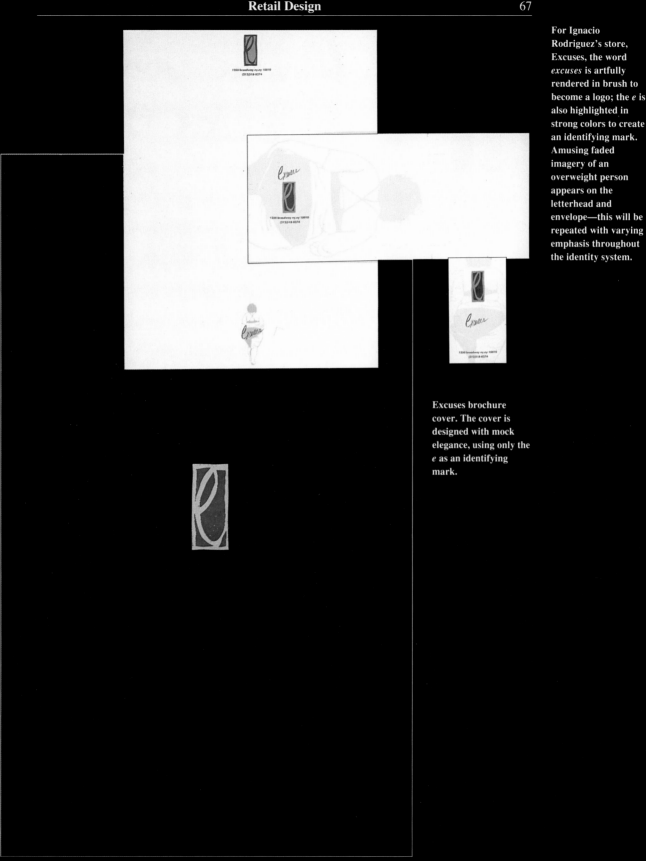

For Ignacio Rodriguez's store, Excuses, the word *excuses* is artfully rendered in brush to become a logo; the *e* is also highlighted in strong colors to create an identifying mark. Amusing faded imagery of an overweight person appears on the letterhead and envelope—this will be repeated with varying emphasis throughout the identity system.

Excuses brochure cover. The cover is designed with mock elegance, using only the *e* as an identifying mark.

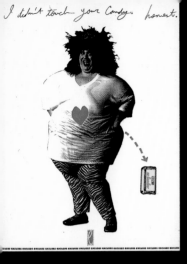

I didn't touch your Candy... honest.

It was under the tree.

Excuses Valentine's Day, Christmas, and Easter posters. A seasonal excuse serves as the headline for each holiday poster. The identifying *e* is applied as a stamp.

Far right: Excuses shopping bag. Various handwriting styles comprise a list of excuses, creating an overall texture for the shopping bag. The identifying *e* becomes the bag's handle.

But easter Bunny dropped it.

"BIG" is beautiful
I JUST QUIT SMOKING
Its a special occasion
IT'S NOT FOR ME.
I need a sugar fix
Its only 200 calories
I have a sweet tooth
THERE WILL BE MORE OF ME TO LOVE.

Claudia Gnaedinger's Zero logo, which combines precise typography and a wild script *e,* is recoupled with geometric shapes to create two candy packages. Throughout all the various uses, the color palettes remain consistent.

Pages 71–73: Zero Christmas, Valentine's Day, and Easter posters. Loose, highly spirited drawings repeat the flavor of the *e* and represent each seasonal holiday appropriately.

Zero folding brochure. Form becomes functional here, as the logo is blown up and split to become the brochure's cover.

TOM WOLFE
FROM BAUHAUS TO OUR HOUSE

TOM WOLFE
THE BONFIRE OF THE VANITIES

TOM WOLFE
THE ELECTRIC KOOL-AID ACID TEST

The Assignment: Create a series of jackets (fronts or fronts and backs) for a series of at least three books. The books should be related by subject matter (in which case there should be a series logo relating to the subject) or by author, and should each have a trim

BOOK JACKET DESIGN

size of 6⅛ by 9¼ inches. Here are three possible series choices:
Series 1. Subject—
Modern American Humor
GEORGE S. KAUFMAN—
COLLECTED LETTERS AND ESSAYS
DOROTHY PARKER—
COLLECTED STORIES AND POEMS
S. J. PERELMAN—
COLLECTED LETTERS AND ESSAYS
H. L. MENCKEN—
COLLECTED ESSAYS
Series 2. Author—
Barbara Tuchman
THE GUNS OF AUGUST
A DISTANT MIRROR
THE MARCH OF FOLLY
Series 3. Author—Tom Wolfe
THE BONFIRE OF THE VANITIES
THE RIGHT STUFF
FROM BAUHAUS TO OUR HOUSE
THE ELECTRIC KOOL-AID ACID TEST

Page 74: The Tom Wolfe series by Lee Bearson relies on Wolfe himself as the key to the format. Playing upon the notion of Wolfe's trademark white suit, the tie serves as a vehicle to differentiate the three books. In addition, this series shows a good example of how typography can complement illustration: The typography maintains a consistent style and position throughout the series and is designed so that the line weights of the type and the drawing are the same.

—— Getting Started ——

A book jacket serves to signal the mood and content of the book. And it must do so immediately—its job is to attract potential readers. Moreover, book jackets compete with each other to serve as promotional vehicles in book stores. In fact, given publishers' shrinking marketing budgets in an uncertain market, the book jacket may be the only serious promotion a book gets.

The problem at hand for this assignment is a little more complicated, however. Because these jackets will function as a series, it is important to create graphics that express the spirit of each individual book while establishing a visual connection throughout the group. The result should have an interrelated appearance. This is particularly challenging for a series of books by a given author, such as Tom Wolfe, since the books' various subject matter may be all over the map.

Before approaching the design of a book jacket, you must do the following: *READ THE BOOK*. You can *never* create the proper visual analogies without an intimate knowledge of the book's subject matter. Don't rely on summaries, word of mouth, or similar shortcuts—if you attempt to design a book jacket without sufficient preparation, you will only expose your ignorance.

—— Establishing an Image ——

Once you have digested the material, the hard part begins: You must create visual symbols to represent the subject matter on the jacket. The subject matter and the spirit of the book create the basis for the jacket's visual image, but it is not necessary to portray the book's entire contents on the jacket. You should simply give the potential consumer a *sense* of what is inside.

Remember that you must consider this visual imagery as it relates to three or more books. This is much more difficult than coming up with a design for just one jacket. For example, you might have some specific images in mind that would serve as the basis of a knockout photographic montage for one of the books; but if you follow through on this idea, you must be able to create something stylistically similar for the other two books, and the specific images you choose must apply to all the subject matter.

If the books are nonfiction, graphic symbols may be appropriate; if they are biographical, portraits may work well. Consider the Modern American Humor series, which features four witty authors, all popular in the 1920s and '30s and each with a unique writing style. Given these similarities, the problem becomes

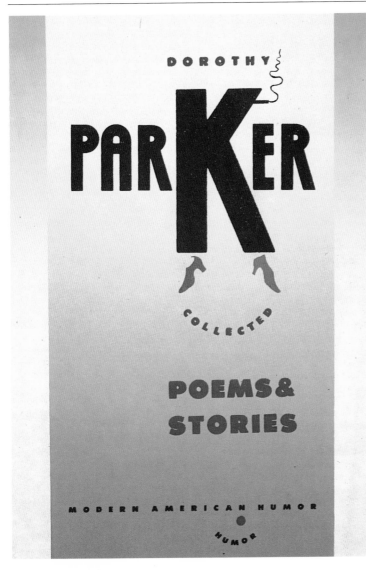

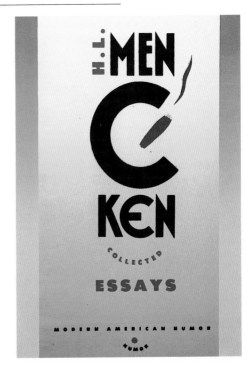

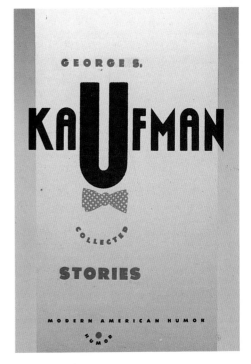

This Modern American Humor series by Ivette Montes De Oca employs typography as its focus. The enlarged letterform in the center of each author's name immediately identifies the books as a series, while the use of pictorial information—the cigar for Mencken, for example—helps create a sense of personality for each author. The similarity of color palettes and use of a border contribute to holding the series together.

Elizabeth Barret relies on humorous illustrations to create a series. Each portrait is reinforced by a decorative spine that repeats a piece of information from the central illustration. The choice of Windsor Bold for the authors' names creates effective contrasts with the illustrations.

one of differentiating the three humorists. Simple portraits are the easiest way but give no clues as to the subjects' unique styles. Symbols become a helpful alternative here. One student used uniquely modified darts to symbolize the writers' pointed humor and singular styles—a rose for the shaft of Dorothy Parker's dart, for instance, and a double-pointed dart for H. L. Mencken. This sort of visual analogy is helpful in making a jacket design more than just a pretty face.

—— Typography ——

After you have settled on the ideas and the style of the visual imagery as it relates to each book, it is time to consider the typography. This area represents your best opportunity to create a visual connection between the various jackets—typographic consistency will make or break the look of the series.

Naturally, select a type style in keeping with the spirit of the jacket's images and visual format. In order to establish and maintain consistency within the series, it is a good idea to create a common position and face for the typography, so the series can be identified while the imagery changes. Consider whether the type can integrate with the art. While the type most often complements the art,

also be alert to the chance for effective contrasts—if the imagery is small, for instance, the type may work well large, or vice versa.

Different series entail different typographic challenges. The Modern American Humor series presents the most formidable task, since the designer must create a series logo, select a type style that works equally well for several authors, and fit in the *Collected Letters and Essays* subhead so it feels as if it always belonged there. For the Tom Wolfe books, in addition to the problem of diverse subject matter, the designer must deal with titles of dramatically different lengths, each of which must appear to fit naturally.

Another possibility is for the typography to essentially *become* the imagery. If this approach is chosen, the layout style should be consistent throughout the series, but there should be distinguishing accents within the typography to diversify the books.

—— Finishing the Jackets ——

After you complete all the design decisions, create a clean comp of each book jacket, with live, properly positioned typography and all appropriate colors. Cut each jacket to size and mount them together on black or white two-ply board.

THE PORTABLE

H. L.

KAUFMAN

COLLECTED

LETTERS

&

STORIES

THE PORTABLE

GEORGE S.

MENCKEN

COLLECTED

ESSAYS

ARTICLES

&

LETTERS

THE PORTABLE

DOROTHY

PARKER

COLLECTED

POEMS

&

STORIES

THE PORTABLE

J.S.

PERELMAN

COLLECTED

LETTERS

&

STORIES

A COLLECTION OF STORIES

DOROTHY PARKER

MODERN AMERICAN HUMOR

Paul Jean relies on
photographic portraits
combined with found
imagery to differentiate
the three authors in his
humor series. He main-
tains design consistency
through the use of the
strong typography
panel at the bottom of
the jacket.

A COLLECTION OF ESSAYS

GEORGE KAUFMAN

MODERN AMERICAN HUMOR

What This Assignment Teaches and Demonstrates

Reading these books and designing their covers will help you master the rudiments of translating literary content into visual imagery, a skill you will draw upon for the rest of your career. It will aid you in designing book jackets, magazine covers, posters, record packages, and similar problems.

Furthermore, book jacket design is one of an employer's best barometers for assessing whether a student is capable of coming up with good ideas. Anyone seeing this assignment in your portfolio will discover your ability to translate editorial information into visual imagery.

For the Barbara
Tuchman series,
Angela Skouras
employs powerful,
large-scale militaristic
imagery to make her
point.

Henry Yee found humorous caricatures of the authors in his series to use as the basis of his jackets. The typographic selection is appropriate to the period in which the authors worked and complements the illustration. The borders serve to house information and create a structure that strengthens the series.

Anthony Ranieri's Modern American Humor series is a strong example of designer research put to good use. Portraits are combined here with imagery that specifically relates to the authors and their work. The overlayered black-and-white photos create a moody effect that is countered nicely by the sense of period and play in the typography.

THE PORTABLE

GEORGE S. ▽▽▽▽▽

KAUFMAN

▲▲▲▲▲▲▲▲▲▲▲▲▲▲

COLLECTED STORIES AND POEMS

The Assignment: Write and design a poster to persuade an audience to a specific viewpoint on a current events issue. The poster should measure 20 by 40 inches and can be horizontal or vertical. Use as much or as little copy as it takes to make your point.

POLITICAL POSTER DESIGN

This assignment, which I have used from time to time over the years, is a terrific way for a young designer to learn about the power of persuasion and propaganda. But it was never a popular project among my students, primarily because the components that make the assignment work are the very things students tend to feel self-conscious about creating (let alone putting in their portfolios).

Page 88: Adam Greiss's *War Is Peace* merges word and image to illustrate the ultimate horror of war.

—— Getting Started ——

The first task here is to select an issue about which you have some strong feelings, such as war, pollution, homelessness, abortion, and so on. Be absolutely clear about your position, and distill it to its purest form—don't equivocate. The final result of the poster should make readers feel as if any other form of thinking on the subject is impossible.

The greatest problem most young designers have in solving this problem is committing to a point of view. They tend to want to show both sides of an issue, perhaps for fear of offending someone with a different point of view, which misses the point of the assignment. Moreover, they are always more concerned with the poster's design than with its *content*.

____ What This Assignment ____ Teaches and Demonstrates

Creating a strong political poster will teach the designer to master the art of propaganda, a powerful tool with the goal of persuading unequivocally, which is invaluable to all forms of advertising. Propaganda is one of the purest forms of the power of design, and can be a dangerous instrument when randomly available for sale. Therefore, it must be used carefully and in keeping with the designer's conscience.

ACID RAIN KILLS

In Elizabeth Barret's *Acid Rain Kills*, a famous Magritte painting is employed to create a horrible vision of death, with the cats and dogs turned upside-down.

"Just cause of war:
To reestablish an
order necessary
for decent
human existence."

-RALPH B. POTTER JR.

"Sweet is war
to those who
have never
experienced it."

- LATIN PROVERB

"The goal
of war
is
peace."

-ARISTOTLE

Palma Prunella
achieves a frightening
irony through shrewd
use of famous quotes
that absurdly "justify"
war.

Steven J. Armieri's *Polly Was a Cracker* uses a childlike illustration to portray the frightening reality of drug abuse.

Paul Jean pairs a horrifying and direct image with a strong headline to achieve a powerful impact.

"IF IT MOVES IT DIES"

Lt. Col. Michael Lustig, United States Marines

"T IEY CAN EITHER COME OUT OR GET OVERRUN," SAID LT. COL MICHAEL LUSTIG WITH THE VII CORPS' 2ND MILITARY INTELLIGENCE BATALLION. "THE WAY THINGS ARE GOING, IF IT MOVES IT DIES."

The Gulf War battle-plan quotation "If it moves, it dies" gains new terror in Ignacio Rodriguez's poster when coupled with an image of a frightened child.

The Assignment: Create a
format and look for a
reissue series of
recordings in the three
standard formats—LPs,
CDs, and cassettes. Two
suggested series are
Modern American
Masters, with records by
Billie Holiday, Bessie
Smith, and Leadbelly, and

RECORD PACKAGE DESIGN

Great American Jazz,
with records by Louis
Armstrong, Duke
Ellington, and Count
Basie; you are also free to
make up your own similar
series for any form of
music.
Your design should
include the following:
1. Square-format front
and back covers for CDs
and LPs
2. Rectangular-format
front and back covers for
cassettes and CD
longboxes
3. An LP inner sleeve
and/or CD booklet
4. An LP label or the CD
itself
Each of these designs
should include the
following typographic
elements:
1. The series logo
2. The name of the
recording artist
3. The name of the album

Getting Started

Page 96: Palma Prunella creates an airy photograph of a paper airplane gliding aimlessly through nothing for an album entitled *Your Mind Is on Vacation*. The letter-spacing in *Vacation* reinforces the mood and the point.

Approaching a record cover is very similar to approaching a book jacket. In the case of a reissue series, such as the one in this assignment, first you must familiarize yourself with the recording artists and the type of music. The best way to do this, obviously, is to listen to the music. Listening to a record, however, provides you with much less specific information than can be obtained by reading a book. Still, you can receive a general feeling that can translate into graphic imagery. Music can be upbeat, mysterious, sentimental, or even abrasive. In any event, the graphics on the package should always reflect the music.

There are many ways to approach imagery on record covers. The most obvious one is to utilize pictures of the recording artists, which is best done by making some graphic connection between the artists and their music. Another way is to key the graphics to the album title, while maintaining some connection to the music.

The music's period, style, and typical audience will also lend some graphic clues. It would be inappropriate, for instance, to design a teen-targeted rock and roll album with the same approach used for a classical album, and vice versa.

While there are no rules governing designs for the various types of music, there are some general guidelines that are worth keeping in mind. Rock and roll covers can be irreverent, rebellious, conceptual, and reflective of contemporary trends. It is best not to follow contemporary fashion, however—instead, create your own, by employing fashion to make a point. Jazz album graphics may be witty, mysterious, conceptual, or moody—it is up to the designer to create the appropriate spirit (which may be suggested by the type of jazz—Dixieland, swing, bebop, or whatever applies). When the album cover relies on images, the typography should complement or contrast with it in an exciting manner.

The material on an inner sleeve or booklet—which may include lyrics, liner notes, additional images, and additional information about the reissue series—should be designed to reflect the spirit of the overall package and reinforce the graphic image established on the cover. If the designer proceeds to design special graphics for the LP label or the CD itself—these elements vary from album to album, generally at the discretion of the record company, sometimes receiving an individualized design and at other times appearing in the company's standardized format—then the spirit of the record cover should be reinforced again.

Finishing the Packages

The record packages should be prepared as comps, cut to size, and mounted on black or white two-ply board, the same procedure as was used for the book jackets.

What This Assignment Teaches and Demonstrates

Music packaging is fun. Most young designers love this assignment and have a natural affinity for creating packages for their specific musical heroes. This project also provides a terrific opportunity to create analogies, puns, parodies, and general irreverence. While the approach here is similar to the one used for the book design and poster design assignments, the lack of written subject matter for the designer to refer to forces the student to think in more abstract terms about how the graphics will relate to the material.

While young designers may enjoy this assignment the most, too much of a good thing can limit other opportunities. There are very few jobs available for young designers within the record industry, so don't assume that having even the most fabulous record packaging samples in your portfolio will land you a job at Geffen.

Potential employers in the record industry respond enthusiastically to well-designed record covers, but art directors in other fields tend to be suspicious, wondering if a young designer will have the same enthusiasm for less "glamorous" work (a problem I have dealt with personally for many years). Unless you are totally committed to working solely in the in the music business, it is best not to create too many record jackets for one's portfolio. However, the skills needed for designing record covers translate well to book jacket design, and record covers therefore receive a certain amount of appreciation from publishing art directors.

Palma Prunella creates her series by use of repetitive illustration. Simplified symbolic instruments for the covers relate to the music on each album. The design format of each cover is identical but can be distinguished by the illustration.

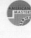

THE PRESERVATION HALL

JAZZ BAND

KITCHEN

MAN

THE PRESERVATION HALL

JAZZ BAND

MATCHBOX

BLUES

THE PRESERVATION HALL

JAZZ BAND

RIFFIN' THE

SCOTCH

Elizabeth Barret approaches her covers illustratively and retains certain common elements throughout all three designs. Objects substituted for heads and busily patterned backgrounds reflect of the album titles.

For Carmel Kahana's Modern American Masters series, the album titles—*Riffin' the Scotch*, *Kitchen Man*, and *Matchbox Blues*—are illustrated by the use of simple photographs of ordinary items. The scale of the objects on the covers and the consistency of the art reinforce the series.

Facing page: Illustration is employed here for two different forms of music. For Kurt Weil, Ron Louie creates George Groz–influenced illustration that is appropriate for Weil's music (top), while Henry Yee illustrates the titles to two American Masters albums.

Moritat
Barbara Song
Pirate Jenny
Alabama Song
Bilbao Song
Surabaya Johnny
September Song
Saga of Jenny
Speak Low
Lost in the Stars

Anthony Ranieri employs a form of comic-strip art to illustrate a series of American Masters albums. The illustrations change with each album, but consistency is maintained through the illustrative style.

John Lee applies an artfully complicated calligraphic approach to this Kurt Weil album and maintains the approach in the design of the highly editorial back-cover and innner-sleeve information.

Paul Jean creates a montage of jazz musicians for his *Golden Era of Jazz* albums. He readjusts the scale of the montage so that the design is equally attractive as the CD cover, longbox, and LP cover, and mimics the color treatment of the packaging to create a design for a special compact disk.

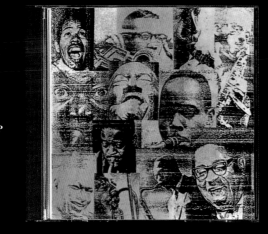

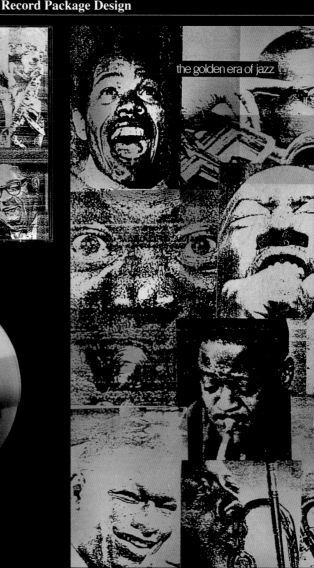

the golden era of jazz

"BABS"
LEE BROWN GONZALES

"CANNONBALL"
JULIAN ADDERLEY

CHARLIE SHAVERS

"C.T."
CLARK TERRY

"DIZZY"
JOHN BIRKS GILLESPIE

JAMES MOODY

JOE WILLIAMS

"KING"
NAT COLE

LEE KONITZ

"LITTLE JAZZ"
ROY ELDRIDGE

"SATCHMO"
LOUIS ARMSTRONG

"STRETCH"
SONNY STITT

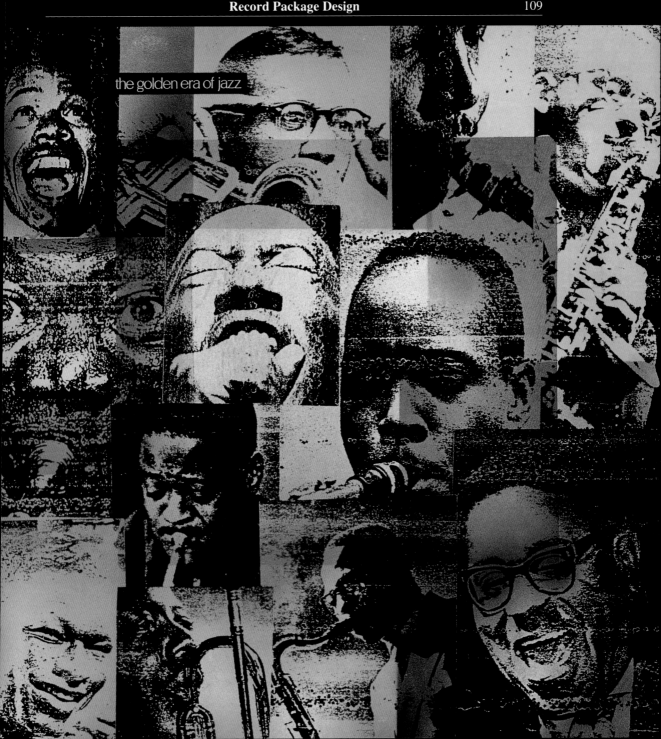

the golden era of jazz

Ignacio Rodriguez
posterizes musical
instruments to create a
design for a jazz series.
The design is so flexible
and well thought out
that it can be adjusted
to work equally well
within the parameters
of the CD cover, the
longbox, and the actual
compact disks.

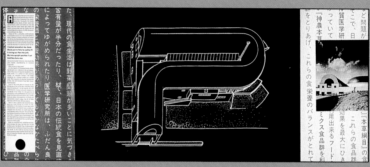

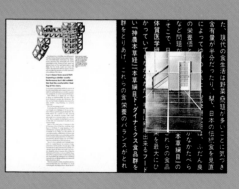

The Assignment: Design
the basic parts of a
magazine, as follows:
1. A logo
2. Three covers
3. A table of contents—a
single page or a spread
4. Departments (short
editorial pieces in the
front or back of the
magazine)—two as single

MAGAZINE DESIGN

pages and one as a spread
5. Features (longer, more
dramatic articles in the
center of the magazine)—
one story running three
spreads, one as a single-
page opener, and one as
four spreads
6. An end page—a single
final page of the
publication, featuring an
essay or series of short
essays, a game, cartoons,
or some form of similarly
engaging information

Magazine design demonstrates a designer's ability to lay out a page, organize information, and combine written and visual material intelligently. A good magazine has a strong identity, so that readers always know where they are, page after page, even when wading through a large number of ad pages. A magazine relies on pacing for its impact, and laying out a magazine is a little like making a movie, complete with a beginning, middle, climax, and conclusion.

—— **Getting Started** ——

Monsider the kind of magazine you would like to design. Instead of creating one from scratch, perhaps you would prefer to redesign an existing one, or maybe you would like to combine the contents of two existing magazines—each of these approaches is valid.

Go to your local newsstand, examine as many magazines as possible, and read those that interest you. You may find that the magazines you like to look at are not necessarily the same ones in which you have an actual interest. This distinction is an important one—don't be seduced by style at the expense of substance. When selecting a magazine to design or redesign, select one with editorial information that genuinely interests you. You will have an easier time designing it and you will do a better job.

—— **The Logo** ——

Once you have determined which real or fictitious magazine you will be designing, turn your attention to the logo. A magazine's logo gives the publication its immediate identity. It may also provide a direction for how to address some of the publication's interior. typography.

The logo should be immediately visible and recognizable on the magazine's cover. Naturally, the type selection for the logo will be greatly affected by the length of the title of the publication. When considering this, draw upon your experience in designing the section logos for the *New York Times*—the skills you honed there will prove invaluable here.

—— **The Cover** ——

After you feel comfortable with your logo design, you should consider its positioning on the cover. As a rule, magazines at a newsstand are positioned so that their tops are visible and their bottoms are not. Therefore, the logo

should be sufficiently large and adequately positioned to be visible at the top.

Before beginning to design the rest of the cover, collect a lot of scrap art, as you did with the *New York Times* assignment. Obviously, the scrap art should be keyed to the stories in the magazine, so either find or create visual material that relates to the feature stories. Don't just get the scrap you'll need for the cover—try to gather enough scrap to supply all the images that will be needed for the feature spreads later on.

Once you have assembled all the necessary material, turn your attention to the actual cover design itself. In addition to the logo, the cover should contain the subhead of the publication, if there is one, small and positioned near the logo or an integral part of the logo. The date, issue number, and price should all be small—legible to the reader upon close inspection but otherwise unobtrusive. And there should be a headline relating to the cover story plus a listing of two or three other articles appearing inside the publication.

This is a lot of typography to get on a cover. Your job is to get all of it on there legibly without destroying the graphic impact of your cover image.

When you are finished, repeat the process for two additional covers.

—— The Table of Contents ——

The contents listing is where you will begin to set up the magazine's typographic structure. It should serve as a bridge between the cover and the interior material, and should contain the following: the logo; the issue date; a listing of the departments and their corresponding page numbers, with or without brief summary descriptions of what the departments contain; and a listing of the features, their authors, and their corresponding page numbers, with brief summary descriptions what each feature contains. Other material that may appear includes a small reproduction of the cover, photos from some of the articles, or a general background photo or illustration.

The contents page can be as simple as a listing or as dramatic as a double-page spread with large photos and giant page numbers. Whatever your approach, it is important to keep the design consistent with the overall editorial spirit of the publication.

Designing the table of contents will entail typographic decisions that you can follow throughout the publication. You will begin to establish a grid—how far will the type sit from the top, bottom, and sides of the page? What system will you use for

page numbers (or *folios*, as they are properly called)? Should the publication's name run in the bottom margin, or maybe on the side? Will you use a bold display typeface for the article titles and a text face for the summary descriptions? These choices will help develop the magazine's overall design.

—— The Departments ——

Departments are a consistent part of every issue, usually on such subjects of current interest as film, theater, art, politics, books, or whatever is germane to the publication's editorial thrust.

It may be helpful to design the department pages together, perhaps even at the same time you design the contents. You must decide upon a grid for the department pages. Consider the various options—two columns? Three columns? Two even columns with a thin third column? You will need a type style for headlines, captions, pull quotes, and folios. Departments sometimes list their authors at the conclusion of each department piece but rarely highlight the authors as feature pieces do, so you may also need to consider a subtle treatment for this.

And you need to establish a text type that will be used throughout all of the magazine's departments.

You must also design the department headings, which are usually single-word topics, such as *Theater*, *Film*, or whatever, although you can make them more interesting if you like. Will they appear similar to their corresponding treatments in the contents listings? Will the treatments of the headings all be the same, or will the be similar but subtly different? Do you want to employ symbols?

The departments should help you establish the feel and continuity of the publication, but it is not necessary to make each department exactly identical. Vary the grid. Allow some images to be bold and others to silhouette or bleed. Naturally, make sure you allow enough room for copy.

Once you have completed the layouts of all three department sections, study them to make sure they give you a feeling of consistency. If not, make the necessary adjustments. Once you are satisfied, examine the covers, contents pages, and departments—you should have established the basic personality of the magazine.

Ivette Montes De Oca employs a panel with bold sans serif type for her *Arete* logo. The colors of the panel and type change for each cover, but the logo's position remains unchanged. The cover headline is positioned differently on each cover to enhance the art appropriately.

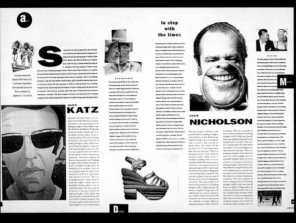

In step with the times

ALEX KATZ

JACK NICHOLSON

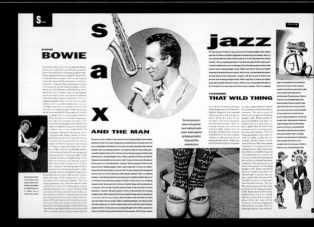

DAVID BOWIE

S A X

jazz

AND THE MAN

FASHION: THAT WILD THING

Montes De Oca's table of contents and department pages utilize the same headlines and text faces, but the layouts are altered for each spread. The use of type dropping out of different geometric shapes adds consistency and diversity simultaneously.

CON-

-TENTS

ARETE

FEATURES

For this "Voodoo" story, Montes De Oca collected voodoo symbols and combined them with a strong wood typeface. The use of the symbols and repetitive typography holds the story together, while the scale changes create drama and flow.

Strong typography and
a powerful photograph
serve to create impact
for the opening of the
"Carnival in Venice"
story. Montes De Oca's
repetition of the same
typographic elements
aids in maintaining
consistency throughout
the feature.

V
E
N
i
c
E

The main purpose of letters is the practical one of making thoughts visible. Ruskin says that all letters are frightful things and to be endured only on occasion, that is to say, in places where the sense of the inscription is of more importance than external ornament. This is a sweeping statement, from which we need not suffer unduly; yet it is doubtful whether there is art in individual letters. The main purpose of letters is the practical one of making thoughts visible. Ruskin says that all letters are frightful things and to be endured only on occasion, that is to say, in places where the sense of the inscription is of more importance than external ornament. This is a sweeping statement, from which we need not suffer unduly; yet it is doubtful whether there is art in individual letters. The main purpose of letters is the practical one of making thoughts visible. Ruskin says that all letters are frightful things and to be endured only on occasion, that is to say, in places where the sense of the inscription is of more importance than external ornament. This is a sweeping statement, from which we need not suffer unduly; yet it is doubtful whether there is art in individual letters. The main purpose of letters is the practical one of making thoughts visible. Ruskin says that all letters are frightful things and to be endured only on occasion, that is to say, in places where the sense of the inscription is of more importance than external ornament. This is a sweeping statement, from which we need not suffer unduly; yet it is doubtful whether there is art in individual letters. The main purpose of letters is the practical one of making thoughts visible. Ruskin says that all letters are frightful things and to

The main purpose of letters is the practical one of making thoughts visible. Ruskin says that all letters are frightful things and to be endured only on occasion, that is to say, in places where the sense of the inscription is of more importance than external ornament. This is a sweeping statement, from which we need not suffer unduly; yet it is doubtful whether there is art in individual letters. The main purpose of letters is the practical one of making thoughts visible. Ruskin says that all letters are frightful things and to be endured only on occasion, that is to say, in places where the sense of the inscription is of more importance than external ornament. This is a sweeping statement, from which we need not suffer unduly; yet it is doubtful whether there is art in individual letters.

By Ann Duffy

i The use of masks has very ancient origins and is strictly linked to the ritual of sacred celebrations. Today, at Carnival time, masks

one of letters is the practical one of making thoughts visible. Ruskin says that all letters are frightful things and to be endured only on occasion, that is to say, in places where the sense of the inscription is of more importance than external ornament. This is a sweeping statement, from which we need not suffer unduly; yet it is doubtful whether there is art in individual letters. The main purpose of letters is the practical one of making thoughts visible. Ruskin says that all letters are frightful things and to be endured only on occasion, that is to say, in places where the sense of the inscription is of more importance than external ornament. This is a sweeping statement, from which we need not suffer unduly; yet it is doubtful whether there is art in individual letters. The main purpose of letters is the practical one of making thoughts visible. Ruskin says that all letters are frightful things and to be endured only on occasion, that is to say, in places where the sense of the inscription is of more importance than external ornament. This is a sweeping statement, from which

The main purpose of letters is the practical one of making thoughts visible. Ruskin says that all letters are frightful things and to be endured only on occasion, that is to say, in places where the sense of the inscription is of more importance than external ornament. This is a sweeping statement, from which we need not suffer unduly; yet it is doubtful whether there is art in individual letters. The main purpose of letters is the practical one of making thoughts visible. Ruskin says that all letters are frightful things and to be endured only on occasion, that is to say, in places where the sense of the inscription is of more importance than external ornament. This is a sweeping statement, from which we need not suffer unduly; yet it is doubtful whether there is art in individual letters. The main purpose of letters is the practical one of making thoughts visible. Ruskin says that all letters are frightful things and to be endured only on occasion, that is to say, in places where the sense of the inscription is of more importance than external ornament.

we need not suffer unduly; yet it is doubtful whether there is art in individual letters. The main purpose of letters is the practical one of making thoughts visible. Ruskin says that all letters are frightful things and to be endured only on occasion, that is to say, in places where the sense of the inscription is of more importance than external ornament. This is a sweeping statement, from which we need not suffer unduly; yet it is doubtful whether there is art in individual letters. The main purpose of letters is the practical one of making thoughts visible. Ruskin says that all letters are frightful things and to be endured only on occasion, that is to say, in places where the sense of the inscription is of more importance than external ornament. This is a sweeping statement, from which we need not suffer unduly; yet it is doubtful whether there is art in individual letters. The main purpose of letters is the practical one of making thoughts visible. Ruskin says that all letters are frightful things and to be endured only on occasion, that is to say, in places where the sense of the inscription is of more importance than external ornament. This is a sweeping statement, from which we need not suffer unduly; yet it is doubtful whether there is art in individual letters. The main purpose of letters is the practical one of making thoughts visible. Ruskin says that all letters are frightful things and to be endured only on occasion, that is to say, in places where the sense of the inscription is of more importance than external ornament. This is a sweeping statement, from which we need not suffer unduly; yet it is doubtful whether there is art in individual letters. The main purpose of letters is the practical one of making thoughts visible. Ruskin says that all letters are frightful things and to be endured only on occasion, that is to say, in places where the sense of the

The significance

of his photographs

derives from

concentration of

PAUL Strand

At the end of 1992, the countries of the European Community will declare open the so-called Single Market, which will lift restrictions on the movement of goods, services, people and capital among the Community's twelve member countries. After the dizzying changes taking place in Eastern Europe, Americans might be tempted to rate this a dull non-event happening a long way from home. They would be fool-

For Montes De Oca's article on Paul Strand, each spread includes a full-page photo. Note the careful attention paid to the consistency of captions and text type.

—— The Features ——

Features appear in the center of the magazine. This area of the publication is known as the *feature well,* because once upon a time the center of a typical magazine had as many as eight stories running consecutively with no advertising. Unfortunately, this is no longer the case—today we are lucky if even one story runs its full length without an ad breaking up the story.

Feature stories should show some editorial balance and relate to the editorial tone of the magazine. For example, a story on a personality, a story on a place or event, and a story about some sort of objects or equipment makes for a nice editorial balance of people, places, and things. It is also helpful if one feature is text-heavy, if one consists of equal parts of words and images, and if one is largely visual.

The feature well gives the designer the chance to show off. Here is where scale and pacing become very important. The stories may maintain the same feel as the departments, or they may vary dramatically—it is your choice. Here is the opportunity to play gorgeous photos against text. You may use large headlines, employ decorative cap initials, bleed photos, create decorative borders, set up identifying running headlines, and so forth.

LEPAGE

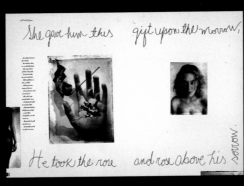

Montes De Oca's "Lepage" article switches gears, offering a softer typographic layout to complement Lepage photography. The consistency is maintained through use of white space and handwriting.

Above all, whatever devices you choose, *be consistent* within a given story. When choosing a typeface for captions, pull quotes, and cap initials, for example, make sure you use them at the same size and in the same way within a story.

Consider ways to create drama through the design of your layouts. For example, if you are designing a four-spread story with a large picture that spreads across the gutter and a column of text appearing on the left, repeat the layout on the second spread. Then, on the third spread, contrast it by laying out an intricate page with lots of pictures and lots of text, and then return to your original layout format for the fourth spread.

When you have finished laying out your feature stories, line them up in order like a storyboard and check the flow. Make sure there is a reasonable balance of pictures and text, that the captions relate plausibly to their images, and that the text flows logically and is easy to read.

The End Page

Consumers picking up a publication at a newsstand often turn to the last page first, so the end page should not be treated lightly. In general, it should echo the feel and spirit of the departments, establishing either an identical or no more than slightly differing feel.

Since there are no firm rules regarding the end page's material, your decisions on what material to include—an essay, a series of short pieces, a game, or whatever—should be based upon the overall contents of the magazine.

Finishing the Magazine

After you have made all of your design decisions, paste up your black typography. If you have set up the type on a computer, run it off in its finished positioning. Then make a clean stat or xerox of the finished, positioned black typography and position your pictorial elements, at their proper sizes and in color, as you laid them out. Mount the images with spray mount so they will be totally flat. If you have intended any color typography, it may already be in position if your type is computerized; if not, add it by using color rubdowns. Make sure your pages are clean and don't show cut marks. Cut the pages to size and mount them on two-ply black Bristol board. Spreads should appear intact; single pages can be shown individually or against ads. If you use ads, pick handsome ones that will not hurt the look of the spread.

If the color comping is fragile, cover the spreads with clear acetate. Spray-mount the acetate to the outside area of the board, but don't

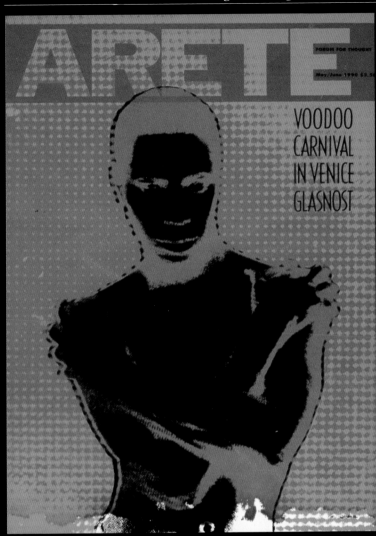

Claudia Gnaedinger integrates her *Arete* logo design and cover art. She then picks up the logo band and background and repeats it on an austere contents page.

spray over the direct area that covers the spread itself.

Finish your covers in the same manner that you finished the book jackets, but mount them individually. Use the same size Bristol board for the covers as you used for the pages.

Sequence the magazine correctly, showing the three covers first and the end page last, and position it in the portfolio.

What This Assignment Teaches and Demonstrates

This assignment, like the *New York Times* project, will help you to master the art of layout. Coming up with scrap that relates well to the intended editorial information, or altering the scrap effectively to make a point, will develop your abilities of conceptualization and art direction. These skills, like all the skills used in magazine design, are useful for every form of editorial design.

A potential employer seeing this work in your portfolio will understand your abilities to lay out and convey editorial information effectively, to design a logo and cover, and to pace a variety of editorial material.

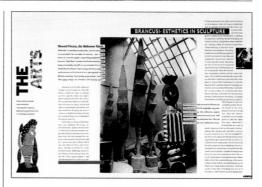

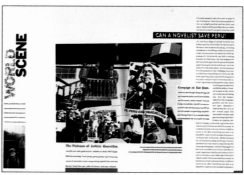

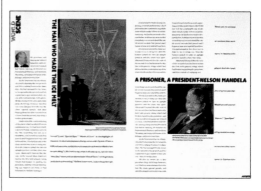

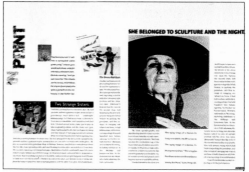

For Gnaedinger's story about the Soviet Union, a Lichtenstein-style illustration uses a word-balloon format for captions. The Lichtenstein pattern and colors are repeated throughout the story.

Gnaedinger's story on
voodoo echoes the
spirit of its subject
matter through the use
of bizarre typography
and color.

In her layouts for photographer Todd Walker, Gnaedinger misaligns photos to reinforce the painterly feeling of Walker's work. Her sensitive use of white space creates a special elegance.

THE PHOTOGRAPHER'S VIEW

TODD WALKER

BY MONIC RAVEL

INTERNATIONAL
DREAMS

Gnaedinger's "Carnival in Venice" story reflects a different mood—the layouts are light, airy, and elegant.

The back page of the magazine, titled as the "Final Analysis," returns to the typographic choices made in the earlier department pages—a nice way of tying things together at the publication's conclusion.

$5 MARCH 89 THE MAGAZINE OF INTERNATIONAL DESIGN

CHAIR MADNESS

Michelle Willems creates a circular logo for her *ID* magazine and artfully positions it on a posterlike cover. The cover story headline runs in an arc around the logo.

The same strong
posterlike approach
used on Willems's
cover can be seen in the
contents and
department pages.

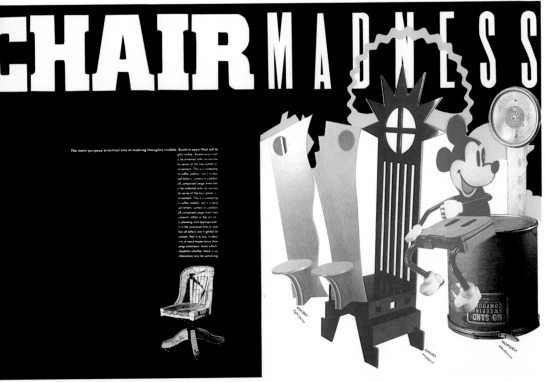

For this story on chair design, Willems employs a complicated die cut that reveals more editorial information after the page is turned.

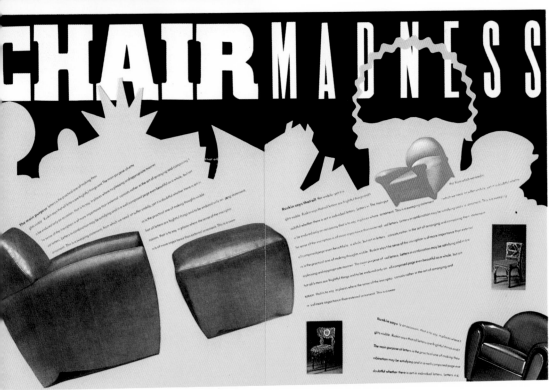

For a story on Michael Graves, Willems tones down the design to allow examples of Graves's work to become the strongest visual elements.

The main purpose of letters is the practical one of making visible. Ruskin says that all letters are frightful things and to be endured only on occasion, that is to say, in places where the sense of the inscription is of more importance than external ornament. This is a sweeping statement, from which we need not suffer unduly, yet it is doubtful whether there is an individual letters. Letters in combination may be satifying and in a well composed page even beautiful as a whole, yet art in letters consists rather in the art of arranging and comparing them in a pleasing and appropriate manner. The main purpose of letters is the practical one of making thoughts visible. Ruskin says that all letters are frightful things and to be endured only on occasion, that is to say, in places where the sense of the inscription is of more importance than external ornament.

by Peter Arnell

HISTORY MOVES FROM MODEL TO MODEL

and page even beautiful as a whole, but art in letters consists rather in the art of arranging and comparing them in a pleasing and appropriate manner. The main purpose of letters is the practical one of making visible. Ruskin says that all letters are frightful things and to be endured only on occasion, that is to say, in places where the sense of the inscription is of more importance than external ornament. This is a sweeping statement, from which we need not suffer unduly, yet it is doubtful whether there is art in individual letters. Letters in combination may be satifying and in a well composed page even beautiful as a whole. **Side**

ate manner. The main purpose of letters is the practical one of making visible. Ruskin says that all letters are frightful things and to be endured only on occasion, that is to say, in places where the sense of the inscription is of more importance than external ornament. This is a sweeping statement, from which we need not suffer unduly, yet it is doubtful whether there is art in individual letters. Letters in combination may be satifying and in a well composed page even beautiful as a whole. **Lounge** art of arranging and comparing manner. The main purpose of letters are satifying and in a well composed page even beautiful as a whole. Ruskin says that all letters are frightful things and to be endured only on occasion, that is to say, in places where the sense of the inscription and more importance than external ornament. This is a sweeping statement, from which we need not suffer unduly, yet it is doubtful whether there is art in individual letters. Letters in combination may be satifying and in a well composed page even beautiful as a whole, but art in letters consists rather in the art of arranging and comparing them in a pleasing and appropriate manner. The main purpose of letters is the practical one of making

Table Prototypes

MAGAZINE OF

INTERNATIONAL

DESIGN

DESIGN IN MOTION

MAGAZINE OF

INTERNATIONAL

DESIGN

C

CONTENTS

EXHIBITIONS

CONFERENCES

DESIGN **RES** U **RCES**

> But I did not feel the
> comfortable tug of
> the risers which
> usually follows an ex-
> hibition jump.
> did not occur to me that
> everything was not
> should be, until
> seconds had passed and
> began to turn over

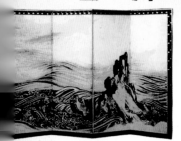

NEW **PR** DUCTS

UNDER
ICE

IT WAS A MOMENT OF SHEER

EUPHORIA. "NOW I FOUND

HER, I WANT TO REACH OUT

AND TOUCH HER." BUT NO

My chute opened quick
and after floating
for a few seconds I cut
loose form the
expecting a similar
formance. But I did not
feel the comfortable
of the risers which usua
ly follows an exhibition

Here Kahana inte-
grates powerful typog-
raphy and imagery.
Note the use of scale
throughout this story.

UGLY

**Funny shapes abound
on great auto classics.**

by Paul Kunzel

CARS

For a photo essay on novelty collections, Kahana employs foldouts, making dramatic use of the horizontal spreads.

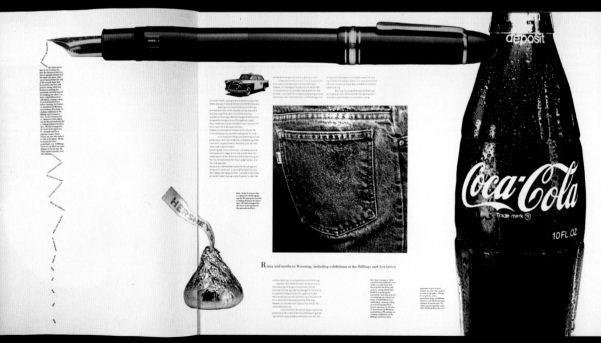

Clockwise from bottom left: Kahana illustrates a story called "Cycle Drama" by beginning with a quiet, elegant opening spread and then moving into a graphically powerful picture spread. He then returns to an elegant, understated layout.

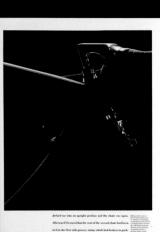

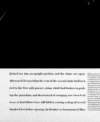

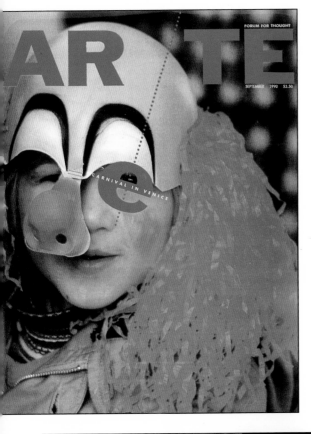

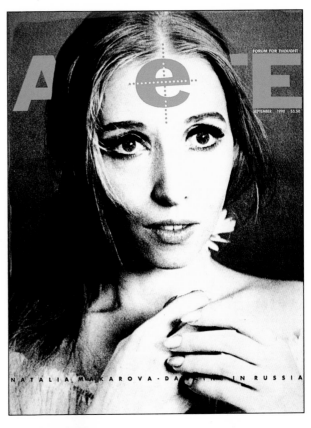

For her *Arete* logo, Katie Jean Hsu highlights the middle *e* and the allows it to move playfully around the cover as it relates to the image. She repeats the *e* treatment on the contents spread.

Hsu's "Carnival in Venice" story gains drama through the juxtaposition of moving typography and lively imagery. The spirited typography appears on each spread of the story, reinforcing consistency.

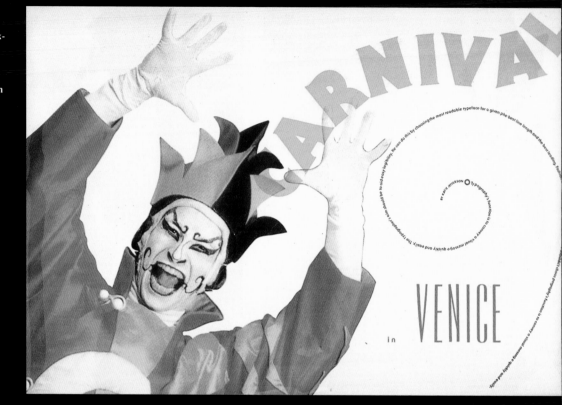

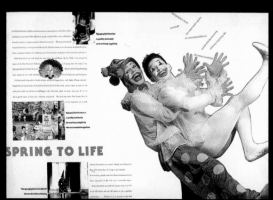

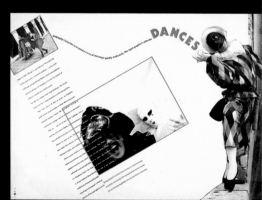

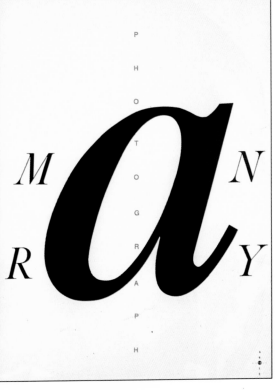

For a feature opener, Hsu uses the common *a* in the first and last names of Man Ray as a balancing point against strong Man Ray photography. She elegantly lays out the following two spreads to show off the photos. Note how the use of white space serves as a counterbalance.

The following assignments
rely on the skills
developed by tackling the
other problems within this
book. Each of them can
add spirit and charm to
an already strong
portfolio.

PROMOTIONAL MATERIAL DESIGN

1. Design the graphics for
a restaurant, including its
menu (cover and interior,
any size you like), its
matchbook, and its
napkins, placemats,
coasters, and so on.

2. Design a promotional
brochure for an upscale
bathroom fixture
company.

3. Design a promotion
piece for a paper company
selling recycled paper.

The Assignment: Design the graphics for a restaurant, including its menu (cover and interior, any size you like), its matchbook, and its napkins, placemats, coasters, and so on.

Page 144: Elizabeth Barret creates a promotion piece for Scott Paper by featuring photos and biographies of famous people named Scott.

Approach this problem in exactly the same way you approached the candy store assignment. Start by selecting an existing restaurant, or make up your own. Once you have the restaurant's name, design a logo. Remember that the name and the logo should reflect the restaurant's spirit.

Apply the logo to a menu cover in some fashion. The logo may be all that appears on the cover, or other visual information may be added. The menu's interior listing should maintain the same graphic spirit as the cover and the logo. Remember the menu's fundamental purpose—it should be treated as information material first and entertainment material second. So if you choose to employ complicated graphics, make sure that the food listing remains legible, or else the menu, however clever it might otherwise be, will become ultimately self-defeating.

Apply the graphics to a matchbook, napkins, a business card, coasters, and so on, each of which can be any size and style that you like. You need not apply the graphics in exactly the same way to each item, but maintain a spirit of consistency throughout the design.

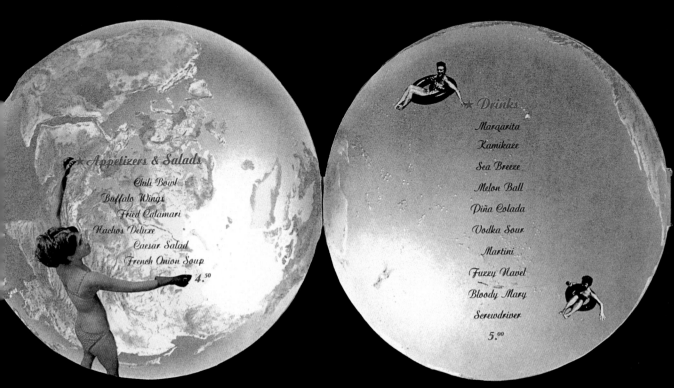

Appetizers & Salads

Chili Bowl
Buffalo Wings
Fried Calamari
Nachos Deluxe
Caesar Salad
French Onion Soup
4.⁵⁰

Drinks

Margarita
Kamikaze
Sea Breeze
Melon Ball
Piña Colada
Vodka Sour
Martini
Fuzzy Navel
Bloody Mary
Screwdriver
5.⁰⁰

Michelle Willems creates a restaurant called Nowhere, utilizing a globe as her central imagery throughout the menu and matchbook (above) and the letterhead, envelope, and business card (page 146).

**The Assignment:
Design a
promotional
brochure for an
upscale bathroom
fixture company.**

For this project (which, by the way, can be varied to suit any store or product), start by designing a brochure. The size and color can be of your choosing; the length should be a minimum of 14 pages, including the cover. The brochure should include a description of the company or product in a one-page introduction, pictures of the product, and appropriate captions to accompany the images.

Approach the design as it relates to the product or store. For Il Bagno (the store name I often use for the assignment—it literally translates to *the bathroom),* for example, there is a broad variety of ways to begin—you can play off the Italian name, create the sense of luxury of an upscale bathroom store, play off the modern design, or accomplish all three at once.

The important thing to remember is that you can bring anything you want to this assignment—the possibilities are limitless. You might want to create a stately booklike feeling to the brochure, adding historical images of the bath; you might opt to posterize photos of the product and make the brochure feel mechanical and graphic; you may want to design the brochure like a miniature home magazine. The choice is yours.

An optional part of the assignment is the additional design of stationery, an envelope, and a business card for the store or product. Obviously, these should all carry the same logo, as well as the store's address, telephone number, and so forth. Moreover, these pieces should have some relationship to each other.

Anthony Ranieri uses tiles and textural patterns from walls and columns to create a specifically Roman flavor for his Il Bagno catalogue. He sets the tone for the design on the cover (page 148, left) and maintains the motif throughout the piece.

Sheri Lee relies on architectural details to create an elegant feeling in her Il Bagno brochure. She utilizes pale pastel shades and a lot of white space to create the airy feeling of the bath.

Anthony Ranieri uses tiles and textural patterns from walls and columns to create a specifically Roman flavor for his Il Bagno catalogue. He sets the tone for the design on the cover (page 148, left) and maintains the motif throughout the piece.

Sheri Lee relies on architectural details to create an elegant feeling in her Il Bagno brochure. She utilizes pale pastel shades and a lot of white space to create the airy feeling of the bath.

The Assignment: Design a promotion piece for a paper company selling recycled paper.

The end result of this assignment can take any form—a booklet, a poster, a game, a newspaper, a series of cards, or whatever. The choice is all yours.

The challenge is to create the vehicle. You need to remember that the object here is to demonstrate the paper's *quality*, as well as the fact that it is recycled. Assume that the paper will exist in a variety of colors, weights, and perhaps even textures.

Before wrestling with the choice of the piece's physical form, first consider its content. Will it be purely informational, or witty, or simply entertaining? When you have settled this issue, the form will follow as a logical conclusion.

What These Assignments Teach and Demonstrate

Depending on the assignment, the student tackling these projects has the opportunity to repeat skills approached in other assignments, probably with more certainty and effectiveness. In the case of the paper promotion, the student can create his or her own design parameters by coming up with the actual concept for the piece.

A potential employer seeing this work gains an understanding of the student's ability to conceive and design effective promotion pieces. These assignments are transferable to all forms of promotional design, so an art director in virtually any field should be able to appreciate them on their own merits.

CHAMPION PAPER

PRESENTS

The

ANNALS

of

PAPER

RECYCLING

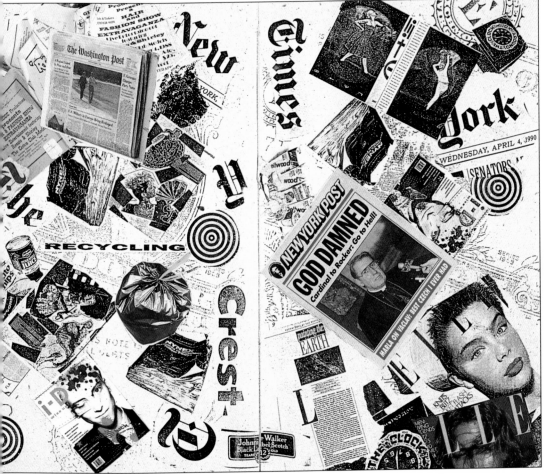

Ivette Montes De Oca creates a promotion piece for a recycled paper firm by documenting the history of printing and then illustrating the growth and eventual ubiquity of printed material. The use of found imagery helps make her point.

EPILOGUE:
BEYOND THE CLASSROOM

Broadly speaking, the assignments in this book demonstrate editorial design, logo design, retail design, package design, promotional design, and poster design. They are structured to take into account marketing considerations and merchandising considerations. Any of these assignments may be partially or completely repeated to broaden the amount of work shown in a portfolio—the designer need only change the subject matter without altering the basic parameters of the problem, and then reconsider the design approach as it applies to the new subject matter.

—— Self-Critique ——

All of the assignments illustrated in the book were produced in the course of extensive critique by me, class discussions, and endless revisions. It is worth noting that revising, or self-editing, is an important part of design—if the initial idea is sound, a design can work, but the details are of critical importance, and therefore must be assessed, revised, and reassessed. So for the student, the question becomes: How do I know when my assignment is designed well enough to be put into a finished form?

The only reasonable answer to this is that it *never* is. What is important is that you feel you have produced the best idea possible, that you have paid careful attention to design details and have improved the piece as much as you can. When you feel confident that you have reached this point, then you are through. The next day, however, you will probably see all the things you could have done to make the piece even better.

When assessing what does and doesn't belong in your portfolio, it is best if you can show your work to a teacher or mentor, or someone whose opinion you trust. If you cannot tell if something is working properly, if the typeface is wrong, if the scale is wrong, and so on, wait a day or two and look at the piece again. With a bit more time to step back, you may be able to see the inevitable flaws. This need not be a disaster or a crisis— every design has its flaws. The goal here is not to have too many of them.

—— Portfolio Presentation ——

As you begin finishing your portfolio pieces, craft becomes very important. Everything should be clean and straight. The colors should be accurate. The pieces should exist in their proper sizes and forms.

Some presentation compromises may be necessary. If the pieces are not all the same size, for example, it will be impossible for each one to be mounted with exactly the same borders. Oversized pieces, like the *New York Times* pages, may have to be folded in half. Posters may have to be reduced in scale. Packages, if they are cumbersome or fragile, may have to be photographed.

Some of these decisions may be influenced by (or end up influencing) the type of portfolio case you choose. The portfolio case should be simply designed and convenient, not cumbersome or complicated. It need not be ornate or have any fancy stamping or leather work—the only thing that matters is your work. The inexpensive, solid-colored plastic cases now on the market will do fine, and the simple, classic black box is always in good taste. Whatever you choose, it is worthwhile to design a label or name tag for the portfolio.

With all of this in mind, several presentation approaches are possible. The key variables are the type of portfolio and the final viewing format of the finished pieces. The various options, along with their varying pros and cons, shape up like this:

1. *A loose-leaf portfolio with acetate-covered pieces*: The portfolio is easy to carry and easy to flip through. The sheets of acetate, however, tend to yellow and dull down the work. Pieces like the *New York Times* pages will have to be reduced. It is impossible to show the candy store material (or, for that matter, any other three-dimensional work) effectively.

2. *A box or zipper-cased portfolio with mounted pieces*: This is effective when all the work can be mounted on identically sized boards. Booklets, brochures, and shopping bags can be inserted into constructed pockets on the boards. One problem is that fragile color work will need to be protected with acetate, which tends to peel up. In addition, the pockets on the board break or bend after only a little handling, giving the portfolio a rumpled appearance. Also, if the boards are too heavy, the portfolio becomes cumbersome and difficult to handle, while lighter boards damage more easily. Over the years, however, most of my students have selected this method and regularly replaced the acetate and broken boards before going on an interview.

3. *A box portfolio with laminated pieces*: This is the most durable portfolio, but lamination obviously won't work on three-dimensional pieces or booklets. In addition, lamination is very expensive and ultimately makes the portfolio quite heavy.

4. *A box portfolio with trimmed-to-size pieces*: This is the most unpretentious presentation. However, fragile pieces that need protection will have to be laminated or else covered in acetate, which will inevitably peel

off. If the portfolio does not have any built-in dividers or some sort of segmenting feature, the small pieces will rattle around and become damaged easily. In short, a high-maintenance portfolio.

5. *A small box with mounted 4 × 5 chromes*: This is the neatest portfolio, but the work must be professionally photographed—an expensive proposition. Also, art directors tend to become suspicious of beautifully photographed student work—it looks as though the student is trying to hide something. If you choose this method, keep the real pieces intact in case you are asked to show them.

6. *A small box portfolio with color-xeroxed work*: This is an accessible portfolio because it is light and doesn't need much protection. The color xerox approach also allows you to make several duplicate portfolios, which is tremendously convenient for job hunting. However, most of the work must be reduced, and color xeroxes can muddy certain colors.

—— Résumés ——

The younger the designer, the longer the résumé. I am always amazed at the résumés from students who have just graduated from art school. The résumé is often two or three pages long and the student is only 22 years old.

It is useless to try to fool anyone. If you have been a student for the past four years, then be a student. It is not necessary to list every part-time job you ever had. Your résumé should simply list where you went to art school and, if you must, your degree; any freelance experience that may be applicable to future employment; and any design awards obtained through school or various competitions.

Don't overdesign your résumé. If you set it up on a computer, don't use justified type—set it up as if it were a typewritten page, flush-left, rag-right, just like a traditional business letter.

In the same vein, don't use Avant Garde, or any other eccentric typeface, and don't use fancy bold headings. In other words, don't make a big deal about it—just let it be a brief résumé.

It is very handy to have some business cards designed as leave-behinds. It may also be a good idea to photocopy samples of your work for art directors to keep, with your name and address attached.

—— Job Hunting ——

The best way to find a job is to look where there is a job opening. Unfortunately, the employment ads in the paper will never be of any use—too

many of the positions listed there are with companies that produce inferior design. It is more important for young designers to find their first professional positions among people who do consistently good work, a standard that limits the job-hunting options severely.

Look at various design compendiums to get a sense of where you would like to be working. Consider firms that you feel are reasonably good or are known for producing good work. Be selective, but also be realistic—if you only admire two design firms and one corporation, you may not be employed for two years.

The first job is very often a matter of luck, being at the right place at the right time. Sometimes you will be hired based on a recommendation or referral from someone who has seen your work previously. Follow every lead, but be prepared to be patient—it may take six months to find your first real job, and you may have to be content doing part-time work in the meantime. If you end up having to support yourself by taking a job with a firm or corporation whose work you don't admire or respect, leave the job as soon as you possibly can, even if you are being paid well. In the beginning, it is more important that you work someplace where you can learn—the money can come later.

After You Drop Off Your Portfolio

Okay, you've finished your portfolio; you've written your résumé; you've attached some business cards; you've enclosed some examples. You've called or written to your greatest design heroes and been told to drop off your portfolio. You drop it off—now what should you expect? Expect *nothing*.

You may end up retrieving your portfolio without speaking to anyone. It may have no note, just a shuffling of the pieces. What does this mean? It may mean any of the following:

- Your hero was too busy to write a note.

- Your hero has no job to offer you.

- Your hero looked at 17 portfolios that week.

- Your hero went out of town, leaving your portfolio to be viewed by an associate. Or it could even mean...

- Your hero didn't like your work.

The key thing to remember here is that none of these reasons is really of any importance. What is important is that you believe in yourself.

The best way to generate a response from a portfolio is to see someone who is willing to make appointments. This person may not be one of your design heroes but may

work for one of them, often with the specific job of screening portfolios and calling attention to new talent. These are the people you want to see.

Different designers will have all kinds of things to say about your work. Some of it will be sugar-coated, some won't be. Pay careful attention to the unflattering comments—if you hear the same remark three or four times, it's probably more than coincidence. Keep in mind, however, that there's nothing necessarily wrong with your work angering designers—it may even be good. Designers are often threatened by new trends, youth, and so on, and you may be hitting a protective nerve. (On the other hand, if you receive a lot of kind, polite response without any results, it may be time to worry.) Of course, don't stubbornly ignore sensible advice, especially if you hear it from several sources, but don't take every subjective comment as the gospel, even from your heroes. Stick to your guns and someone will discover you.

—— Your Portfolio's Evolution ——

A portfolio is an evolving set of work, and compiling one is an ongoing process. You will always have a portfolio in one form or another, and your school pieces eventually will be replaced as

you begin to collect printed samples of your professional work. In three or four years, the school portfolio vanishes, leaving a body of printed work standing in its place.

It is important to understand this now, while you are working on these student assignments, so that you can come to grips with the very temporary nature of your situation. You are not making work carved in stone or creating a personal legacy; you are creating pieces that are representative of your current abilities. As you grow and change, so will your portfolio. What matters now is not what you made, but what you learned by making it.

Design is a process of ongoing learning. In this context, a portfolio should create a clear picture of how *little* you know and how much *more* you have to learn and discover. You discover by designing, by looking at other work, and by participating in the world at large. The reality is that the truly great designers never really complete portfolios, because they always continue to grow.

INDEX